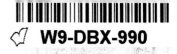

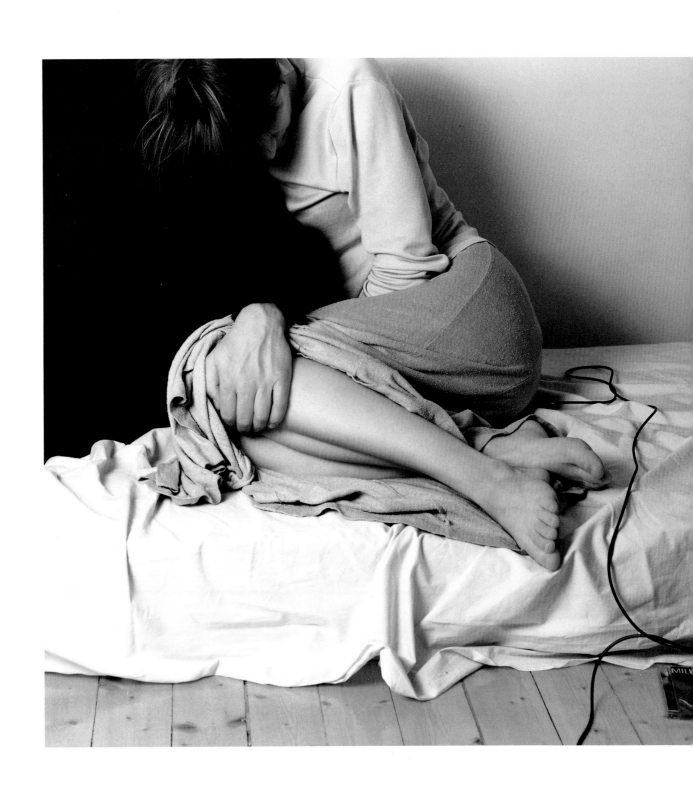

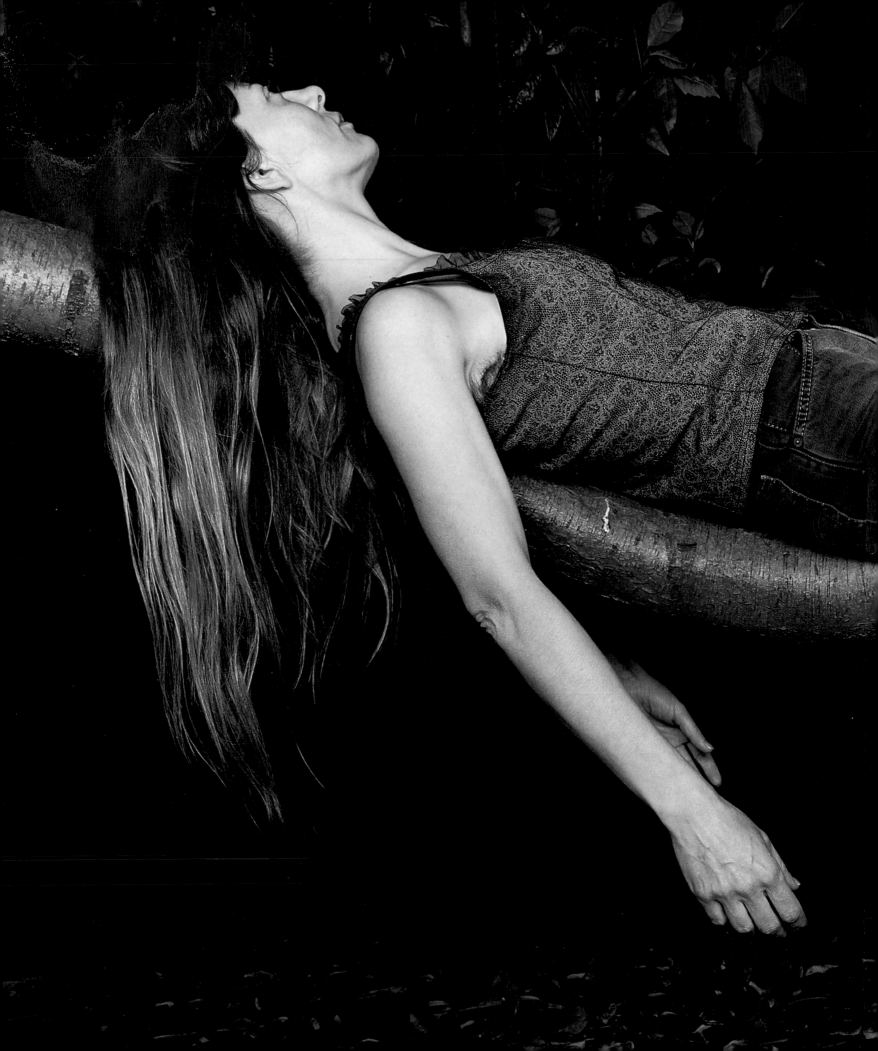

GIRLS' NIGHT OUT

ELIZABETH ARMSTRONG
IRENE HOFMANN

with essays by
TARU ELFVING
BILL HORRIGAN

GIRLS' NIGHT OUT

ORANGE COUNTY MUSEUM OF ART
Newport Beach, California

This catalogue was published on the occasion of the exhibition *Girls' Night Out*, organized by the Orange County Museum of Art. *Girls' Night Out* is presented by Neutrogena Corporation.

Additional support has been provided by James B. Pick and Rosalyn M. Laudati, Joan and Don Beall, Visionaries, LEF Foundation, the Women's Consortium of the Orange County Museum of Art, Christine and Jeff Masonek, FRAME Finnish Fund for Art Exchange, Anita Kunin Fund of The Minneapolis Foundation, and an anonymous donor.

Exhibition Itinerary

Orange County Museum of Art, Newport Beach, California
September 14, 2003–January 25, 2004

Contemporary Art Museum, Saint Louis
September 16–December 31, 2005

Blaffer Gallery, the Art Museum of the University of Houston
January 21–April 2, 2006

Published by the
Orange County Museum of Art
850 San Clemente Drive
Newport Beach, California 92660

Edited by Karen Jacobson
Designed by Catherine Lorenz
Printed and bound in Germany by Cantz

Library of Congress Cataloging-in-Publication Data

Girls' night out / exhibition curated by Elizabeth Armstrong and Irene Hofmann; essays by Taru Elfving and Bill Horrigan.
 p. cm.
"Published on the occasion of the exhibition Girls' night out, Orange County Museum of Art, Newport Beach, September 14, 2003–January 25, 2004, Contemporary Art Museum, St. Louis, September 16–December 31 2005."
Includes bibliographical references.
ISBN 0-917493-36-2 (pbk. : alk. paper)
1. Women in art—Exhibitions. 2. Feminism and the arts—Exhibitions. 3. Arts, Modern—20th century—Exhibitions. 4. Arts, Modern—21st century—Exhibitions. I. Armstrong, Elizabeth, 1952– II. Hofmann, Irene. III. Orange County Museum of Art (Calif.) IV. Contemporary Art Museum.
NX652.W6G57 2003
704'.042'0904507479496—dc21
2003013624

Front cover:
Daniela Rossell
Untitled (Ricas y famosas), 2001 (detail)
Cat. no. 60

Back cover:
Dorit Cypis
The Rest in Motion 1, 2002 (detail)
Cat. no. 25

Page 1:
Elina Brotherus
False Memories II, 1999
Cat. no. 9

Pages 2–3:
Sarah Jones
The Park, 2002
Cat. no. 52

Page 4:
Dorit Cypis
The Rest in Motion 1, 2002
Cat. no. 25

8

It is with great pride that Neutrogena announces its committed and ongoing support of the arts by sponsoring the Orange County Museum of Art's exhibition *Girls' Night Out*. A leading manufacturer of premium skin, hair, and cosmetics products, Neutrogena has an insightful understanding of women. Neutrogena has a desire to see women be their healthy best, not merely on the surface, but in all areas of their lives.

Girls' Night Out is a strong and affirmative celebration of women's empowerment through the works of an international group of female artists who portray women acting on their inner desires, dreams, and aspirations in groundbreaking photography and video. Like this exhibition, Neutrogena celebrates the power of female identity and applauds these talented and creative women for sharing their inspiring and artistic vision.

Eija-Liisa Ahtila
The Scenographer's Mind V, 2002
Two color prints, mounted, framed as a set, with hand-colored mat
46 1/2 x 71 in. (118 x 180 cm)
Courtesy Klemens Gasser & Tanja Grunert, New York

Girls' Night Out, which marks a renewed engagement with contemporary art at the Orange County Museum of Art, is the first thematic exhibition organized for the museum by our curatorial team of Elizabeth Armstrong, deputy director for programs and chief curator, and Irene Hofmann, curator of contemporary art. The female photographers and video artists in *Girls' Night Out*, representing two generations from six different countries, are reclaiming for themselves and the viewer a more subjective, poetic, and nuanced approach to portraying women. Although conscious of issues of representation and identity explored over the past three decades, they nonetheless set a different yet equally compelling course. The emotional complexity, descriptive detail, and confessional qualities of their work are for me more literary, recalling the writings of Adrienne Rich and Sylvia Plath rather than the imperatives of critical theory, and are infused by Rich's vision of "a woman sworn to lucidity who sees through the mayhem."

Girls' Night Out encompasses many of the ideas and curatorial approaches that will define the Orange County Museum of Art's programming in years to come: a willingness to explore and help promote independent positions, the presentation and interpretation of challenging work that considers the needs of broader audiences, an international perspective grounded in local concerns, the support of new work created in collaboration with community groups, and the intersections of popular culture with the visual arts.

Every day I have the pleasure of coming to work with Elizabeth Armstrong and Irene Hofmann,

two extraordinary "girls" who bring verve, intelligence, and openness to everything they do. Thanks also to Taru Elfving and Bill Horrigan, who have contributed insightful essays to the catalogue. *Girls' Night Out* will go on the road after its presentation at the Orange Country Museum of Art, traveling to the Contemporary Art Museum, Saint Louis, and the Blaffer Gallery, the Art Museum of the University of Houston. I am grateful to my colleagues at each institution—Paul Ha in Saint Louis and Terrie Sultan in Houston—for their belief in the exhibition.

A major undertaking like *Girls' Night Out* requires the support and encouragement of many donors, and I'm delighted to thank our corporate sponsor, Neutrogena, for understanding the importance of this project. Lisa Fritz Wallender, director of public relations, and LaVaun Vawter, manager of community relations, knew immediately that Neutrogena and the museum would be great partners for this exhibition. I also thank the additional foundations and organizations that have helped provide the institution with the means to build our program, as well as our key patrons, who have been unwavering in their commitment to the museum.

Dennis Szakacs
Director

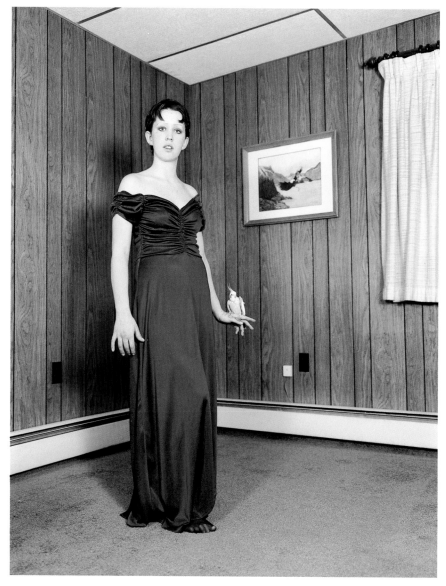

Katy Grannan
Untitled (from the Poughkeepsie Journal), 1998
Cat. no. 38

Girls' Night Out grew out of a shared interest in the work of a younger generation of women artists, working primarily in photography and video, who have revitalized classical subject matter with fresh and provocative inquiries into identity. Victor Zamudio-Taylor, the independent curator with whom I co-organized *Ultrabaroque: Aspects of Post–Latin American Art* (Museum of Contemporary Art, San Diego, 2000), first brought several of these artists to my attention, and he was integral to the early development of the exhibition at the Orange County Museum of Art (OCMA). He helped draft the conceptual underpinnings of the exhibition and visited a number of artists' studios with me. When Irene Hofmann, curator of contemporary art, joined the curatorial staff at OCMA, she had been thinking along similar lines and brought with her suggestions for several additional artists as well as an enthusiasm for collaboration on this project. Her participation in virtually every aspect of the exhibition's organization, including her careful oversight of the catalogue and her excellent essays on each of the artists, has been critical. As curators, we were struck by the powerful new poetics of content and form evident in the work of many female artists, which transcended earlier inquiries into identity marked by concerns with gender, sexuality, and race. The exhibition gave us the opportunity to work with a number of these artists and connect their work to broader impulses in art and culture today.

In addition to Irene Hofmann and Victor Zamudio-Taylor, I want to thank OCMA's new director, Dennis Szakacs, for his keen interest in *Girls' Night Out*. Even before he had officially moved into his West Coast office, he was pursuing avenues of support for the exhibition. In this regard, I also wish to thank our corporate sponsor, Neutrogena Corporation, for its enthusiasm for this project. Likewise, I'm deeply appreciative of the museum's Board of Trustees, which has been tremendously encouraging and supportive of this endeavor. Many OCMA trustees personally played a crucial role in the success of this project, and I want to acknowledge the following for their generous

funding: James B. Pick and Rosalyn M. Laudati, Joan and Don Beall, and Christine and Jeff Masonek. I am indebted to the LEF Foundation for its generous grant support, as well as to the Visionaries, one of the museum's most important support groups, for its early commitment to this project. We also were fortunate to receive additional funding from the Anita Kunin Fund of The Minneapolis Foundation, FRAME Finnish Fund for Art Exchange, and the Women's Consortium of the Orange County Museum of Art.

The essays of two scholars enliven this publication, and I wish to thank Taru Elfving, an art historian and independent critic living in London, and Bill Horrigan, curator of media arts at the Wexner Center for the Arts, Columbus, Ohio, for the excellent texts they have contributed. We share with them our gratitude to our editor, Karen Jacobson, whose insight, enthusiasm, and discernment served immeasurably to bring this book to fruition. We are also grateful to Catherine Lorenz, who infused this volume with her wonderful energy and design expertise, which are fully evident in its pages.

During the course of planning the exhibition, there were many others whose contributions to the project we have depended on and greatly valued: Pedro Alonzo, Jeb Bonner, Beth Burns, Lane Coburn, Isabel and Agustin Coppel, Marc Foxx, Angela Jones, Kati Kirinen, John Messner, Debra and Dennis Scholl, Marketta Seppala, Michael Solway, Rochelle Steiner, and Jennifer Wells. Also crucial to the project was the support and kind assistance of the staff at the artists' galleries, especially Jeanne Greenberg Rohatyn and Sima Familant at Artemis Greenberg Van Doren Gallery, New York; Fernanda Arruda at Anton Kern Gallery, New York; Olivier Belot at Galerie Yvon Lambert, Paris; Tanja Grunert, Klemens Gasser, and Ashley Ludwig at Klemens Gasser & Tanja Grunert, Inc., New York; Birgid Uccia and Bob van Orsouw at Galerie Bob van Orsouw, Zurich; Solene Guillier at &: gb agency, Paris; Francesca Kaufmann at Galleria Francesca Kaufmann, Milan; Rose Lord and Catherine Belloy at Marian Goodman Gallery, New York; Molly McIver and Carol

Greene at Greene Naftali Inc., New York; and James Lavender and
Maureen Paley at Maureen Paley Interim Art, London.

The participation of the other arts institutions on the
exhibition tour has extended the life of the exhibition, and we are
pleased to acknowledge and thank key colleagues at the other
museums: Paul Ha and Shannon Fitzgerald at the Contemporary Art
Museum, Saint Louis, and Terrie Sultan at Blaffer Gallery, the Art
Museum of the University of Houston. We greatly appreciate their
support and enthusiasm for this undertaking.

We wish to thank our many colleagues at OCMA whose
support also made this project possible. Janet Lomax provided
invaluable help with coordinating the myriad details of exhibition-
related correspondence, travel, and catalogue texts; Brian Boyer and
Dan Rossiter dedicated themselves with great skill to the installation;
Tom Callas organized all of our loans, shipping, and the many details
of the exhibition's tour; Susan Swinburne, Laurie McGahey, and Anne
Parilla tirelessly focused their energies on exhibition fund-raising; and
Brian Langston kept watch over related press and marketing. Other
staff members who have spent many hours on various aspects of this
undertaking include David Curtius, Ursula Cyga, Lisa Finzio, Jennifer
Katz, Joe Kearby, Carol Lincoln, Jeanine McWhorter, Calleen
Ringstad, Robin Rutherford, Ron Scott, Joni Tom, and Sarah Vure.
We greatly appreciate their efforts and those of the entire OCMA
staff in support of this exhibition.

Finally, my heartfelt appreciation goes to the *Girls' Night Out*
artists not only for their deep respect for human potential and fragility
but also for their willingness to share themselves so intimately in their
work. I hope that their eloquent and poignant images provoke
dialogue and inspire reflection on the part of viewers, as they have for
me and my family. In this regard, I am indebted to my daughters,
Olivia and Phoebe, for their self-will, vulnerability, strength, and
love—they are my inspiration.

Elizabeth Armstrong

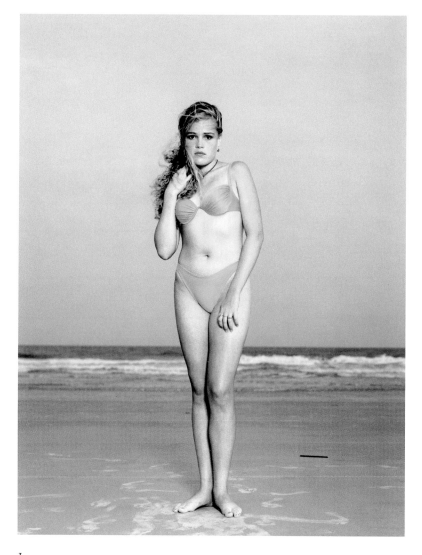

1
Rineke Dijkstra
Hilton Head Island, South Carolina, USA, June 24, 1992, 1992
C-print
24 1/2 x 20 1/2 in. (62 x 52 cm)
Courtesy of the artist and Marian Goodman Gallery, New York

Elizabeth Armstrong

> I'm a captive of my own image and my attempts to escape are
> my works of art.
>
> Salla Tykkä[1]

Each generation reformulates its story. In organizing *Girls' Night Out*,
we were inspired by what we observed as a generational shift in
contemporary visual art—one that reflects a more open and complex
approach to identity in recent photography and video. The exhibition
encompasses work produced during the past decade by an
international and intergenerational group of women: Eija-Liisa Ahtila
(b. 1959, lives in Helsinki), Elina Brotherus (b. 1972, lives in Paris),
Dorit Cypis (b. 1951, lives in Los Angeles), Rineke Dijkstra (b. 1959,
lives in Amsterdam), Katy Grannan (b. 1969, lives in New York City),
Sarah Jones (b. 1959, lives in London), Kelly Nipper (b. 1971, lives in
Los Angeles), Daniela Rossell (b. 1973, lives in Mexico City), Shirana
Shahbazi (b. 1974, lives in Zurich), and Salla Tykkä (b. 1973, lives in
Helsinki). Bringing a divergent range of expression to their
exploration of identity, these artists share an interest in classical genres
such as portraiture, architectural space, and landscape, as well as a
respect for a rigorously formalistic approach to technique and subject.

 Some of the most influential art made in recent decades has
focused on issues of identity, and women artists of previous
generations, from Hannah Wilke (1940–1993) to Cindy Sherman
(b. 1954), are well known for their critiques of the stereotypes of
femininity. Although the historical context for *Girls' Night Out* is
informed by the pioneering conceptual and aesthetic stance of these
artistic forerunners, the work in the exhibition nevertheless reflects
a new sensibility that has grown out of the influence of feminism
and the corresponding progress women have been able to achieve.
As Simon Taylor has written with respect to the experience of
women artists:

Despite persistent bias and discrimination, there *has been* a qualitative change for women artists in the past thirty years. Being a woman artist is no longer viewed as a handicap, and female art students can reasonably expect to exhibit in museums and galleries once they graduate. . . . While the women artist's movement may have suffered setbacks, notably in the backlash decade of the 1980s, many improvements in the situation of the woman artist have been secured. . . . Women now occupy positions of power, not merely as patrons, benefactors and philanthropists, but in the actual work of directing museums, curating exhibitions, publishing books, editing magazines, teaching university courses, etc., so the patriarchal control of artworld institutions has changed— and women artists are the beneficiaries of this democratization.[2]

I would argue that women today are able to explore complex and contradictory notions of femininity without having to defend or valorize past feminist gender issues, and they are consequently more likely to define identity in more ambiguous terms, drawing on their own subjectivities and multiple potentialities.

Central to *Girls' Night Out* is the idea of the *girl*—a term that has regained currency when applied to women in an affirmative manner, especially by women—and the exhibition's title reflects a generational shift that has brought the use of this word back into play. Although youth culture has dominated fashion and the popular media since the 1960s, with an emphasis on girlish styles and bodies, the early feminist movement of the 1960s and 1970s, also known as the women's movement, was focused on asserting the independence and power of women. The use of the term *girl*, when applied to grown women, was considered patronizing and demeaning. In recent years, the word *girl* has been reclaimed by a wide range of young women,

from political activists to those working in the mass media. Legions of young feminists organizing in the late 1980s and 1990s called themselves Riot Grrrls, and girls and women writing for zines such as *Bust* and *Bitch* took on the name Girlies. In the 1990s magazines like *Sassy* in the United States and *Dolly* in Australia documented young women claiming the formerly male domain of rock and roll, as well as reclaiming "girly" things, from nail polish to the color pink (but assiduously avoided the dieting articles and dating tips that are the standard fare of conventional young women's magazines).

In the fall 1997 "Girl" issue of *Spin*, rock critic Ann Powers wrote: "Girl Culture girls have transformed what it means to be female in the nineties. Unlike conventional feminism, which focused on women's socially imposed weaknesses, Girl Culture assumes that women are free agents in the world, that they start out strong and the odds are in their favor."3 The signs of girl culture are ubiquitous. While thinking about this exhibition, I was struck by the accessories worn by my preteen daughters: T-shirts, hats, and necklaces bearing slogans such as "You Go Girl," "No Boys Allowed," and "Girls Rule." But the ascendancy of girl-ness and its groundswell in contemporary culture have actually been in evidence since the 1980s. Pop singer Cyndi Lauper, who released the hit song "Girls Just Want to Have Fun" in 1983, might be seen as a proto-girl. A movie of the same title, starring a then unknown Sarah Jessica Parker, was released to wide popular success in 1985. In 1984 Madonna came out with her landmark album *Like a Virgin*, which included the cut "Material Girl." British TV sitcoms such as Jennifer Saunders's self-critical *Girls on Top* (1985–86), and later her hilarious *Absolutely Fabulous* (1992–96, 2001), were refreshing signs of change on the small screen. And in 1988 a new feminist-based magazine for teenage girls called *Sassy* hit the newsstands.

In the 1990s television was enlivened by a plethora of female stars who, however "girly" and "ditzy" they might appear, had

2
Hannah Wilke
What Does This Represent?
What Do You Represent? 1978–84
Gelatin silver print
Variable dimensions
Hannah Wilke Collection and Archive,
Los Angeles, California
Courtesy SolwayJones, Los Angeles

18

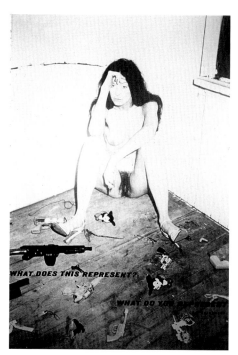

prominent roles and witty dialogue that were empowering in their own way—sexy and smart. Actors such as Sarah Jessica Parker of *Sex and the City*, Calista Flockhart of *Ally McBeal*, and Sarah Michelle Gellar of *Buffy the Vampire Slayer* nevertheless represent idealized Hollywood types. More individuated are some of the younger female musicians who have dominated the pop music scene over the past decade, including Aaliyah, Mary J. Blige, Bjork, Macy Gray, Alicia Keyes, Avril Lavigne, Alanis Morissette, Liz Phair, and Portishead. Also closer in spirit to the work in *Girls' Night Out* is a spate of recent films written and directed by young women—such as Nicole Holofcener's *Lovely and Amazing* (2002), Rebecca Miller's *Personal Velocity* (2002), Samira Makhmalbaf's *At Five in the Afternoon* (2003), and Lisa Cholodenko's *Laurel Canyon* (2003)—which have greatly increased the number of complex female characters portrayed on the wide screen.

The evolution of a new girl culture—and the increasingly central and empowered role that girls and women have played in politics, the mass media, and other professions—finds its parallel in the art world. Feminist artists of the late 1960s and 1970s drastically changed the content of traditional media such as painting and sculpture and at the same time pushed photography, performance, video, and installation art to the fore. Using their own bodies, artists such as Valie Export, Carolee Schneemann, and Hannah Wilke brought a performative mode to their art that challenged the way that women had been portrayed—and objectified—in art and in the mass media. In her lifelong series of self-portraits, Wilke inserted her naked body into her art, and by becoming simultaneously subject and object, she both exaggerated and deflated the eroticization of the "male gaze" conventionally brought to the image of the female nude (fig. 2). Flaunting her sexuality, she aggressively confronted her audience and used the seductive potential of her femininity in performances that were gestures of sexual autonomy and empowerment.

3
Cindy Sherman
Untitled Film Still #6, 1977
Gelatin silver print
8 x 10 in. (20.3 x 25.4 cm)
Courtesy of the artist and Metro Pictures,
New York

Wilke also made videos in the 1970s that documented and expanded on her performances, as did Eleanor Antin, Lynda Benglis, Adrian Piper, Martha Rosler, and Martha Wilson, to name a few feminists working in new media. Rosler's video *Semiotics of the Kitchen* (1975) features a robotic housewife who wields kitchen utensils as if they were instruments of violence. Rosler's simultaneously funny and scary portrayal of this antithesis of the perfect housewife calls into question the prescribed sphere of domesticity for women while, as other commentators have noted, also alluding to "women's undeveloped power and suppressed rage."[4] In his essay for this catalogue, Bill Horrigan references the critical contributions of the first generation of women video artists, who—in addition to challenging representations of sexuality, race, and gender—asserted female subjectivity as a legitimate subject for art.

In the late 1970s a new wave of women artists—including Jenny Holzer, Barbara Kruger, and Sherrie Levine—engaged in their own brand of sexual politics, focusing on gendered representation in art, art history, the media, and popular culture. One of the most important artists of this generation was Cindy Sherman, who continued Wilke's critique of images of women that reflect a male perspective but employed new strategies for doing so. Like Wilke, Sherman works in a performative mode, serving as her own model, but unlike Wilke, she veils and disguises her own identity. In her now-famous series Untitled Film Stills (1977–80), Sherman represented various female character types from old B movies and film noir (fig. 3). Through her reenactments of the stereotypical ways in which women and the female body have traditionally been depicted, she drew attention to the power of media images to shape ideas of female identity. Sherman's images, combining parody with social critique, often portray women as victims and flaunt their femininity, holding it at a distance.

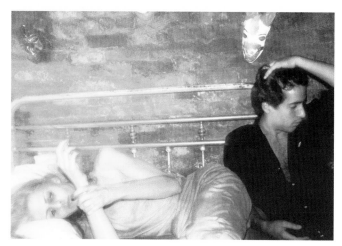

4
Nan Goldin
Greer and Robert on the Bed, 1982,
from *The Ballad of Sexual Dependency*
Cibachrome color print
30 x 40 in. (76.2 x 101.6 cm)
Courtesy Nan Goldin and Matthew Marks Gallery,
New York

The role of representation in defining identity was a central topic of art in the 1980s, and photography lent itself ably to this critique. The art press of the decade was dominated by discussion of the "Pictures" generation—including such artists as Kruger, Levine, Sherman, Jack Goldstein, and Richard Prince—whose work was largely characterized by the appropriation and reconstruction of pictures made by others. One notable artist of this generation who used photography but followed a distinctly different path was Nan Goldin (b. 1953). Drawing on the tradition of documentary and fashion photography, Goldin has created a highly personal and disturbing commentary by opening up her own private life and the lives of her friends and lovers to the unflinching eye of the camera (fig. 4). Her provocative images have captured the most intimate details of lives enmeshed in love, sex, drugs, violence, and addiction. Rich in saturated colors and art historical references (her images have often been compared with paintings by artists such as Caravaggio and Jan Vermeer), Goldin's images have a low-life edginess and seductive glamour. Her glaringly brutal portraits of herself and her "tribe," culminating in *The Ballad of Sexual Dependency* (1981–96), brought a new subjectivity and journalistic approach to the art photography of this period.

Much of the art in *Girls' Night Out* falls somewhere between Sherman's performative work, focused on a fictive staging of self, and Goldin's documentary reportage, in which her subjects represent themselves. Employing what might be called a staged or performative realism, many of the artists in *Girls' Night Out* take an almost ethnographic approach to their subjects, and it is sometimes difficult to assess the degree to which their sitters are complicit. Indeed, some of the subjects have only just met the artists and agreed to pose for them, others serve as more neutral formal elements, and still others are friends or actors playing their parts in staged tableaux.

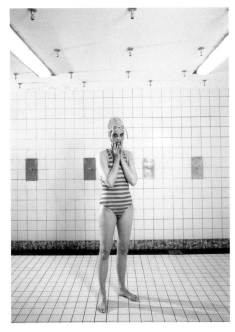

5
Rineke Dijkstra
*Self-Portrait, Marnixbad, Amsterdam,
Netherlands, June 19, 1991*, 1991
C-print
60 1/4 x 50 3/4 in. (153 x 129 cm)
Courtesy Marian Goodman Gallery,
New York

The Dutch artist Rineke Dijkstra began her career in the 1980s working on commission for newspapers, magazines, and annual reports. Struck by the practiced poses of the businessmen and other professionals she usually photographed, who knew exactly how they wanted to present themselves, Dijkstra gravitated in her personal work to portraits that would have, in her words, a "naked immediacy." Her early work has been described as being situated somewhere between the photographs of August Sander (1876–1964) and Diane Arbus (1923–1971), two major influences acknowledged by the artist. Dijkstra shares Sander's systematic, taxonomic approach to portraiture in combination with tremendous sensitivity to the individual's expression, gesture, posture, and costume. Like Arbus, she reveals the unusual lurking beneath the everyday, and she shares Arbus's often-quoted goal of working in "the gap between intention and effect."

In the early 1990s Dijkstra began a series of bathers that epitomized what would become her trademark blending of a formal classicism with psychological intensity. The series started in the Netherlands with her own self-portrait, taken after a long and exhausting swim (fig. 5), then moved to beaches in the United States and, after that, Eastern Europe. In the United States she was struck by what seemed to her a particularly American sensibility among teenagers, "who take their examples from photos in glamour magazines they want to imitate."[5] In *Hilton Head Island, South Carolina, USA, June 24, 1992* (1992; fig. 1), the subject, a teenage beauty queen who seems to be pulling in her stomach as she tries to strike a natural pose, evinces an underlying anxiety. For Dijkstra, the self-consciousness of posing reveals something essential about her subjects. Her camera manages to portray, in her words, "what we don't want to show anymore but still feel."[6]

Dijkstra's video installation *The Buzz Club, Liverpool, England / Mystery World, Zaandam, Netherlands* (1996–97; fig. 27)

6
Sarah Jones
The Dining Room Table (III), 1998
C-print on aluminum
60 x 60 in. (150 x 150 cm)
Courtesy Maureen Paley Interim Art, London

features young clubbers at a Liverpool disco and a Dutch techno club. Delving more deeply into the phenomenon of adolescence, she invited teenagers at the nightclubs to dance for the camera. The twenty-six-minute video is a mesmerizing look at kids responding to the thumping disco-techno music blasting in the clubs, just off camera. Dijkstra's technique is part cinema verité, part ethnographic document (of youth fashion, facial expressions, and body language). At first, viewers—feeling like voyeurs—are as uncomfortable as the subjects being portrayed, but they are ultimately swept into the spirit of the video as the young dancers waver between awkward self-consciousness and ecstatic loss of self, transported by their sensual immersion in the music and dance. Says Dijkstra: "In the process of photographing it becomes clear to me what I am looking for. Usually it's closely related to my own experience. In the disco girls, I recognise my own desire for rapture."[7]

British artist Sarah Jones also focuses primarily on portraiture, but she broadens the frame to include details of architectural interiors and landscapes. The privileged homes of bourgeois British families serve as one of the central settings for her carefully composed domestic environments. Appearing placid and serene, subdued teenage girls sit in suspended animation, as if their lives were on hold (fig. 6). An almost claustrophobic impression of confinement makes it seem all the more crucial that the girls move on. Their outward indifference belies a subconscious struggle for self-discovery, further suggested by the occasional subject crouching beneath a table or by Jones's complementary series of photographs of recently vacated couches in psychoanalysts' offices (fig. 59). The contradictions and tensions at the heart of this work, in which the staid settings stand in stark contrast to the emotional turmoil commonly associated with adolescence, energize the works and create a dramatic subtext.

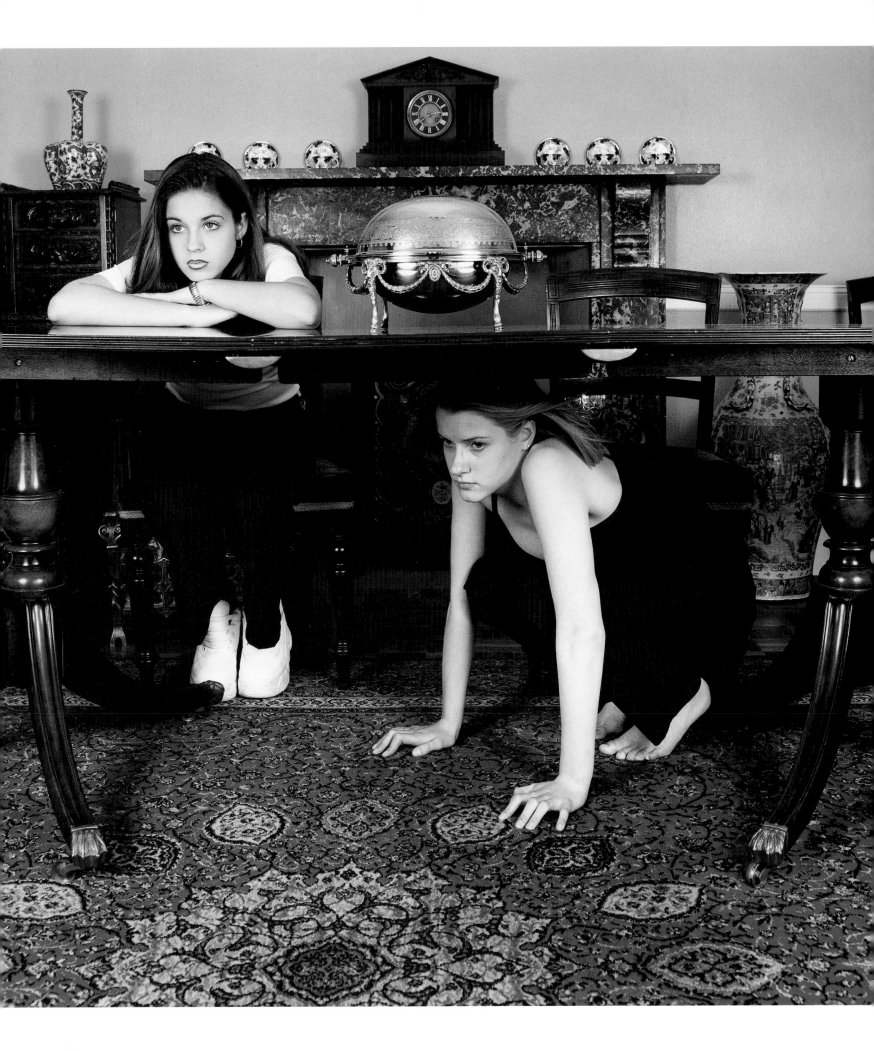

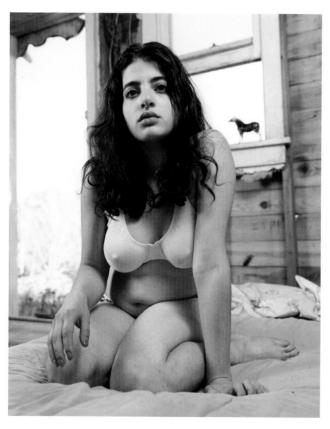

24

Jones's rich and elegant compositions have been compared with those of sixteenth- and seventeenth-century Dutch and Flemish masters, who were keenly aware of the significance of rooms as well as the gestures of the people in them. Other works sometimes suggest art historical references to painters such as Piero della Francesca, Diego Velázquez, Jean-Auguste-Dominique Ingres, and Edouard Manet. In her series entitled Actor, she worked with professional actors, who were directed to assume a static pose and mimic the gaze of one of the figures from Piero's Brera Altarpiece (1472–74). Writing about the Renaissance painter, the art historian Bernard Berenson noted that Piero's figures "exude a strange inverse reaction between expression and expressiveness: they show no emotion, yet arouse a strong response in us."[8] In the same way that Jones denied the actors their method and their identity, the girls in her domestic interiors and landscapes tend to mask their personalities before the camera. Recalling Ingres's society portraits of the mid-nineteenth century, in which his poised female sitters gaze out blankly but enigmatically, Jones's portraits take on a hypnotic aura of mysterious reverie.

In contrast to Jones's carefully staged photographs, the work of New York artist Katy Grannan is more candid in nature (fig. 7). Grannan—who, like Jones, often references European painting—makes portraits of anonymous, middle-class Americans. Grannan's technique is straightforward: she places ads in small-town newspapers, soliciting subjects to pose for photographs in their own houses and milieus and making it clear that the photographer is a female artist. It has been argued that photography depends on the art of seduction and accommodation—skills at which women are often particularly adept. The number of responses Grannan receives to her ads, and the openness of her sitters, may well be a result of her gender. As the photojournalist Mary Ellen Mark observed: "I can walk down any street in the world and knock on the door, and they'll let me in.

Women are less threatening and have an easier time getting access to strangers."9 Grannan's remarkably intimate portraits of relative strangers are striking evidence of this.

Grannan shares with Rineke Dijkstra, whose work she admired as a student in the graduate photography department at Yale University, an interest in "transformative" moments. Grannan tries to find the moment when her subjects have let go of their own pose but have not yet assumed a new one. Their choices of clothing, gestures, and settings for the photographs, although sometimes amended by the artist, are highly revealing. Many of the young women who answer her ads are posing without their parents' knowledge, and an unspoken sense of secrecy and complicity bonds artist and sitter. The awkward familiarity of her subjects' unremarkable domestic surroundings (often their childhood homes), which Grannan manages to transform into theatrical settings, elicits a voyeuristic interest and empathy.

More successful as poseurs are Daniela Rossell's subjects, who are often members of the Mexican upper class. Rossell's young female sitters seem closer to the female stereotypes of Cindy Sherman's photographs than to the real people featured in Grannan or Dijkstra's portraits. Although most of Rossell's images are not staged by the artist, it is almost impossible to distinguish between the sitters' images of themselves and their "authentic" selves. Taking an ethnographic approach to society portraiture, Rossell suggests the intricate merging of her sitters' subjective and social identities, in the same way that their personal aesthetics have become indistinguishable from designer fantasies. The quasi-baroque interiors captured by Rossell are even more claustrophobic than those in Jones's photographs, and the sitters' gestures and expressions are even more closely guarded.

In her series *Ricas y famosas*, Rossell's subjects are family members, friends, and acquaintances, and this creates an unusual sense of intimacy between artist and sitter. Aware that the artist would be

Daniela Rossell
Untitled (Ricas y famosas), 2001
Cat. no. 60

26

publishing these photographs, the subjects nonetheless seem unconscious of how the images might be interpreted by the public. The pretentious surroundings, designer clothes, and other signs of excessive consumption reveal lavishly lived fantasies that would be right at home on the TV show *Lifestyles of the Rich and Famous.* Rossell's portraits convey a dizzyingly surreal effect. One image, reminiscent of Sandro Botticelli's *Birth of Venus* (after 1482), shows a woman, scantily draped in diaphanous blue tulle, standing in precarious rapture at the edge of an infinity pool elevated high above a sweeping view of the wealthy suburbs of Monterrey, Mexico (fig. 8). This large-format print—with its striking panoramic composition and radiant palette of blues, aquas, and greens—exemplifies the strength and power of Rossell's visual vocabulary. Equally surreal is the formidable success of the illusion created by her sitters, whose sheer theatricality ironically highlights their vulnerability.

A world away from the opulence and illusion of Rossell's photographs, Iranian-born Shirana Shahbazi focuses on the mundane aspects of life in Iran. Although her images are documentary in style and some are shot spontaneously on the street, most are staged. In her ongoing series *Goftare Nik (Good Words)* (2000–2003; fig. 9), she juxtaposes her reportage-like photographs with paintings made in collaboration with billboard painters (figs. 72, 73). The latter images, which show women in veils and austere ayatollahs, correspond to Western stereotypes. Her own images—of women and men, mothers and children, working women, landscapes, and cityscapes—are widely diverse and not immediately identifiable as portrayals of Iran and its people.

The artist, who grew up and was educated in Germany, was born in Tehran and makes regular trips there to create new work. Her own bicultural experience allows for a transcultural approach. In her site-specific, floor-to-ceiling montage arrangements, she juxtaposes

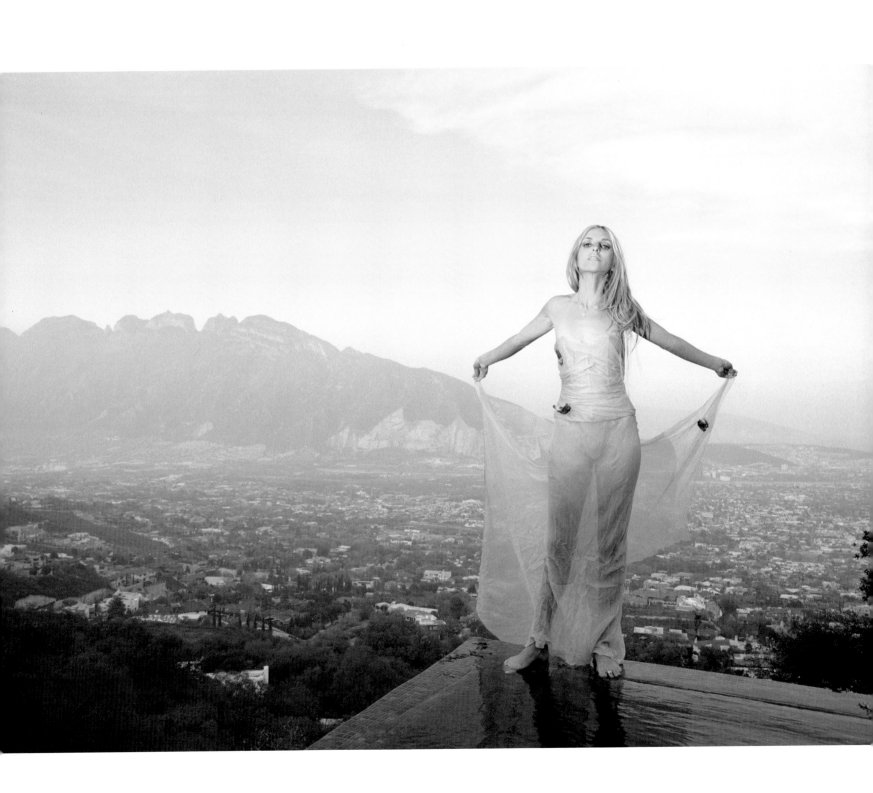

paintings with photographs, the familiar with the foreign: an image of a young veiled woman smoking a cigarette, next to a picture of an old-fashioned Iranian billboard, next to a photograph of an urban freeway. Celebrating and finding beauty in banality and offering an alternative to cultural clichés, she does not pass judgment as she examines the often contradictory identity of Iran, and especially Iranian women, today—poised between Islamic tradition and contemporary Western life.

The work of Finnish artist Eija-Liisa Ahtila finds its own unique balance between the documentary and the staged, between fact and fiction. Her filmic and still works combine the skills of a visual artist and filmmaker who cuts through complex narratives to touch on psychological revelations. (Ahtila attended art school and UCLA's Film, TV, Theater, and Multimedia Studio program.) While employing documentary techniques, she interweaves special and surrealistic effects to dramatize her ideas. Ahtila's *If 6 Was 9* (1995–96; fig. 31) is a video installation and film about teenage girls and sexuality. The piece, based on research and real events, includes recollections from the artist and others of their own experiences of sexual awakening, but she places these stories in the mouths of five teenage girls, ages thirteen to fifteen. Through the conflation of the women's words and the girls' voices, Ahtila alludes to the complexity of identity, suggesting that each individual is a composite of past and present selves that is continually being reconstituted.

In *If 6 Was 9*, Ahtila presented a girl's-eye view of life that is raw in its honesty. She has continued to borrow from documentary research and personal experiences while moving her narratives into the quicksand terrain of psychotic behavior, including hallucinations, obsessions, and phobias. Footage from some of these longer dramatizations was edited to make *Lahja—The Present* (2001; figs. 32–35), a group of five one-to-two-minute DVDs presented on five

9
Shirana Shahbazi
From *Goftare Nik / Good Words*, 2000–2003
Cat. no. 62

monitors (it also includes thirty-second TV spots made at the same time as the installation itself). In this work Ahtila displays her remarkable capacity to plunge the viewer into the narrative's most urgent moments. "The Bridge," for instance, follows the painful progress of a woman who knows that she is acting crazy but can cross a bridge in her neighborhood only by crawling across it on her hands and knees (fig. 30). In another segment, Ahtila focuses on an adolescent girl on her way home from school. As the girl walks into her barren yard, she carefully bypasses a mud puddle, hesitates, looks up at the house (is someone watching her?) and back down again; then she promptly returns to lie down on her back in the middle of the puddle (fig. 26). After lying there for a minute, she gets up, covered with wet mud, and walks into the house. At the close of each segment, there is a text that reads: "Give yourself a present, forgive yourself." Combining tough scrutiny with immense empathy, Ahtila creates powerful works that address desire and loss, catharsis and survival.

Ahtila has exerted a critical influence on a younger generation of Finnish artists, including Salla Tykkä, whose more autobiographical works explore her personal struggle with the social and cultural constructs of femininity. In her earliest work, which documents her own coming of age, she presents the female body as a battleground, riven by external pressures and internal demons. In an early video, *Bitch—Portrait of the Happy One* (1997), Tykkä presents herself as a glamour girl, stepping out of a limousine, walking down a red carpet, surrounded by adoring fans. In a series of three photographs entitled *Sick*, *More Sick*, and *The Sickest One* (1997; figs. 14–16), she found a way to deal with anorexia, staging her recurring fears as a way to combat them.[10]

Tykkä sometimes employs Ahtila's quasi-surreal, cinematic approach to the moving image. The artist's recent video *Thriller* (2001;

fig. 79) explores the feelings of a girl confronted by her own sexual awakening. With a highly charged resonance (and deep, vaginal reds) that evokes the films of Ingmar Bergman and David Lynch, in which the lines between dream and reality are often blurred, Tykkä creates a scenario stretched taut by the sexual tension between a man and a young girl (father and daughter?). Rather than portraying the young girl as a passive victim, she presents a role reversal. When the protagonist is unable to act on her desire, she turns to violence. Tykkä further intensifies the piece's psychological punch by leaving the narrative open-ended, raising unanswered questions about the girl's consciousness of her own motivation and the man's role in awakening her desire.

Tykkä's uninhibited exploration of female sexuality comes after years of discourse about the representation of women in art and the mass media. As an artist and a teacher, Dorit Cypis has played an important role in this discourse, which is reflected in the evolution of her own body of work. Cypis—who was born in Israel, grew up in Canada, and lives in Los Angeles—has consistently prodded cultural assumptions about female identity, and her subjective exploration of identity anticipated the sensibility found in *Girls' Night Out*. Her interactive portraits of the 1980s gave her performers control over their own representation as she allowed them to pose in response to projected images, often from the subject's personal archive. This work was inspired by the same drive that directs Cypis's activities outside conventional art making. For instance, she founded an interactive arts program, called Kulture Klub, that brings together artists and inner-city homeless and at-risk youth, and she is currently enrolled in a graduate program in mediation.

In her pivotal work *Yield (the Body)* (1989; fig. 10), Cypis called attention to the difference between "the gaze of the woman" and "the gaze by the woman." Characteristically open and unfettered by

inhibition, the piece includes a large nude self-portrait, along with twenty-eight small nude photographs of the artist that she commissioned from four other female photographers (including Nan Goldin), in an attempt to see how women looked at other women, as opposed to the familiar "male gaze" of art and pornography. Cypis's gentle sensuality affirms female sexuality and its centrality in women's lives (as well as in the domain of feminist ideology).

Throughout the 1990s Cypis has further shifted her focus from the gendered body to the ineffable body (memory, time, location). Her willingness to delve deeper into subjective exploration has resulted in a powerful new group of images. As in her earlier installations and environments, the large scale of the photographs and their disorienting layers of imagery place the viewer both inside (the interior experience) and outside (the direct experience) what becomes a private and public space. The multiple planes and refractions of *Prisoner's Dilemma 1* (2002; fig. 44) create a double reality. As we determine whether or not we are looking at the artist herself or at her reflection, her physicality becomes secondary. Do we know only what we see, or do we see what we somehow already know? For Cypis, the mirror, which allows one to see and be seen, functions as an indefinable interval between perception and phenomenon, between the observable body and intuitive essence. In *The Rest in Motion 2* (2002; fig. 12), human presence is suggested through its absence, replaced by the swelling forms of a curtain blowing in the wind. Its sensual allure suggests the strangeness of an out-of-body experience and our daily navigation of the dimensions of consciousness. The seductive shape—of curtain or human—is ultimately a temporal experience, a destabilized subjectivity.

Sharing with Cypis an interest in the metaphysical, California-based Kelly Nipper explores the relationship between motion, time, the body, and space. In an early performance piece,

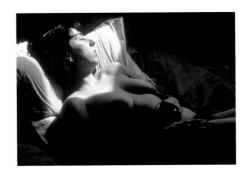

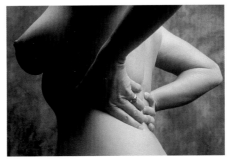

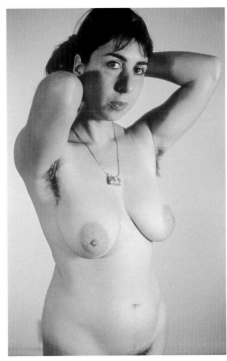

11
Kelly Nipper
Movement with Chalk, 1998
Framed chromogenic process color print
49 x 63 in. (124.5 x 160 cm)
Courtesy galleria francesca kaufmann, Milan

12
Dorit Cypis
The Rest in Motion 2, 2002
Cat. no. 26

32

BLOND (1995), a person, almost completely wrapped in white terry cloth, with only an opening for the mouth, hovered in a subzero room, chewing gum and silently blowing bubbles. The eerie, enigmatic quality of this performance and the minimal aesthetic of its white-on-white environment prefigure Nipper's later installations, photographs, and videos in which actions appear to happen outside of time. In her large-scale photographs, such as *Movement with Chalk* (1998; fig. 11), in which a young woman conjures a magical cloud of chalk dust, the figures seem to be performing silent meditations. Her exquisitely staged and balanced tableaux, whether they feature figures or still-life objects, are marked by a poetic quietude.

Nipper's recent video entitled *Bending Water into a Heart Shape* (2003; fig. 66) bridges stillness with continuous motion. Setting herself and her subject an impossible task, Nipper worked with a young dancer and a martial arts instructor for months to perform the sustained movement of an ice skater's triple-lutz jump, extended over a period of one hour. Instead of filming the lutz and slowing down its split-second movement, Nipper filmed in real time, working with the dancer to create a highly controlled, excruciatingly slow-moving Butoh-like performance. Influenced by the American choreographer Merce Cunningham, her multiscreen video captures the intensity of the challenge that the dancer and the artist set for themselves, allowing us to observe their humanity when they fail to achieve perfection.

Finnish-born Elina Brotherus also takes a poignant approach to failure in an entirely different setting: the student and her teacher in the dance studio. In her single-channel video *Lesson* (1998; fig. 28), the artist is the beleaguered student, attempting to perform a short and simple ballet but unable to follow the directions of her teacher. Berated by the teacher for her missteps, Brotherus captures the humiliating experience of youthful failure with the humor and

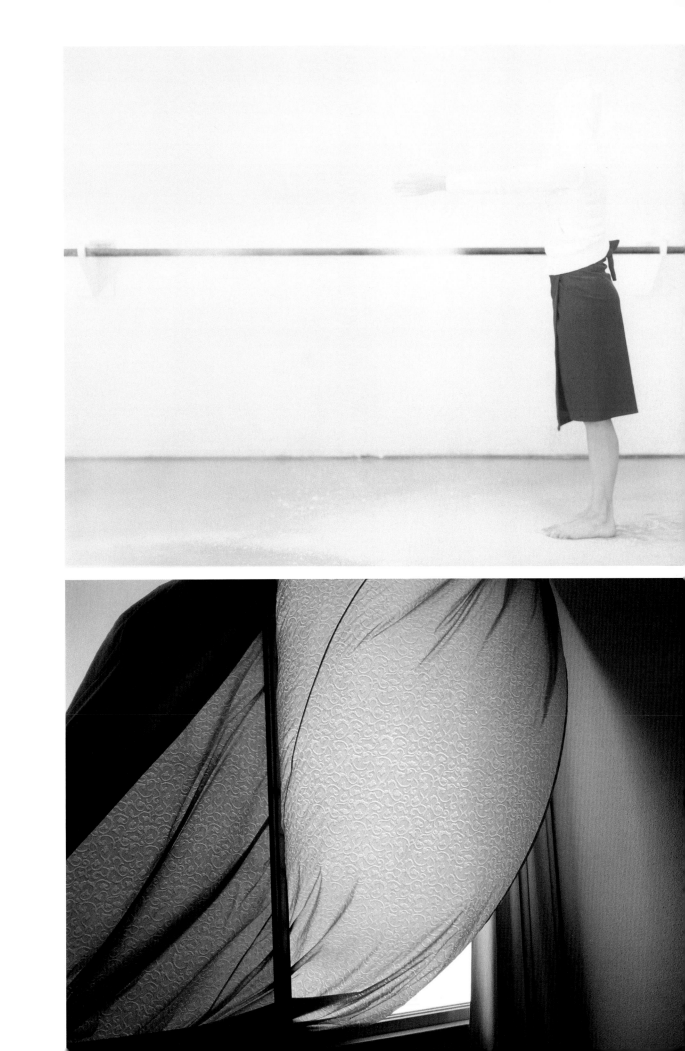

34

retrospect of an adult. She is not afraid to confront her own weaknesses and imperfections. For instance, *Revenue* (1999; fig. 41) portrays the artist's arrival in France for a period of residency. Standing in her new, minimally furnished room, in a country where she does not yet grasp the language, she looks utterly bereft, like a lost little girl. Brotherus's autobiographical works follow one young woman's attempts to find her place in the world; her formal asceticism and critical distance are countered by the intimacy of her self-scrutiny.

Brotherus presents herself in a simple, unaffected way that is disarming in its directness and breathtaking in its beauty. During the period when she made works such as *Love Bites II* (1999; fig. 13) and *Femme à sa toilette* (2001; fig. 40), she kept her camera on a tripod in a corner of her room in order to grow accustomed to its presence. That way, she could more readily photograph herself in an emotionally unguarded state before pulling herself together. Brotherus's work is compelled not so much by the perspective of a seasoned feminist as by the seemingly limitless possibilities that she faces in defining her own identity. In her art, as in so much of the imagery in *Girls' Night Out*, one is struck by the loneliness of the pursuit and the sense of displacement that accompanies meaningful self-exploration.

The artists in *Girls' Night Out*, each in her own very distinct way, seek to strip away or unveil the outward trappings of womanhood. In contrast to Cindy Sherman's remarkable review of the myriad masks imposed on and worn by women, the work in *Girls' Night Out* reflects an interest in what's beneath the surface. In getting inside the bodies and minds of her subjects, Ahtila exposes the impact on women's psyches of constructing and wearing the mask. Dijkstra waits patiently behind her camera for the moment when the mask drops. Grannan works with her youthful models to find a place outside the pose. Tykkä struggles to free herself from imposed social models by sharing some of the most painful and intimate moments of

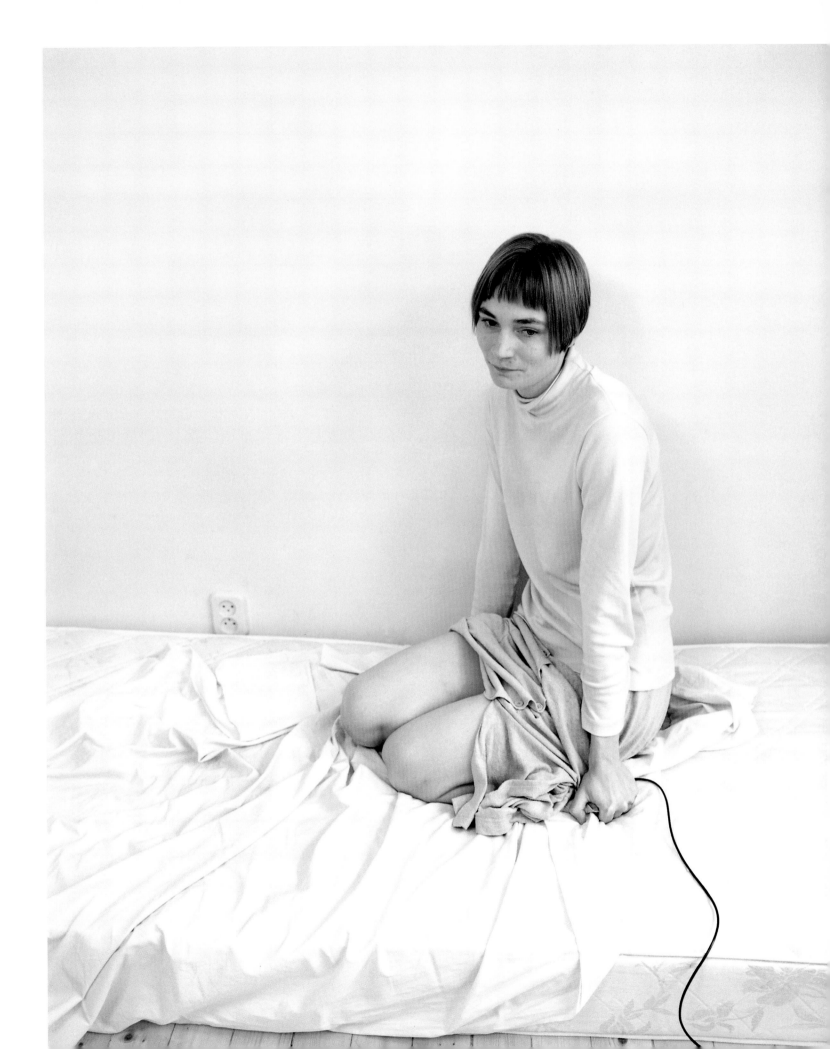

growing up. The formal beauty of Nipper's work coexists with the chance occurrences and self-revelations beneath the surface. Shahbazi's girls and women navigate the contradictory divide between Islamic tradition and modern Western society, literally between veiling and unveiling. The masked faces of Jones's adolescent subjects cast a pall over her scenes, their composed expressions locked into prescribed roles and premature atrophy. Rossell reminds us of the entrapment of the mask, of its ability to subsume or subvert the self. In her innumerable self-portraits and landscapes, Brotherus shares the lonely pursuit of self-determination outside social imperatives. Cypis suggests the ongoing desire for self-discovery and an openness to the unknown—she reminds us of the possibilities in letting the mask slip away.

As a mother with two girls on the brink of adolescence, I am particularly aware of the ironic gap between our positions. While they are working to create their own mature identities, I am struggling to retain aspects of their childhood selves—not so much their innocence, but their openness to new experiences and feelings. My recognition of my desire to transcend this divide brings me to an exploration of uncertainty and multiple possibilities. In her essay in this volume, Taru Elfving, drawing on postmodernist feminist psychoanalytic theory, argues that the fluid and evolving nature of the adolescent girl's identity—her inability, as child-woman, to fit neatly into categories of age and gender—makes her a particularly compelling subject. As Elfving points out, "there is radical potential in this impossible position."

Through their exploration of this potential, the artists in *Girls' Night Out* offer a multiplicity of glimpses into the personal and social space that we inhabit today. They confidently portray girls and women, as well as boys and men, in relation to private and public contexts, without the need to challenge or critique stereotypes and, perhaps more significantly, with a critical honesty that transcends

satire and irony, putting their faith in the power of the unconscious and the unseen. In their works, identity is less about socially assigned roles and more about an investigation of subjective experience. The images they present are at once poetic and disturbing, haunting and beautiful, groundbreaking and classic. Here the "girl" does not represent the feminine per se but instead embodies a vulnerability and at the same time a sense of unbounded potentiality that are essentially human.

NOTES

1. Artist's statement, 2001.

2. Simon Taylor, "The Women Artists' Movement: From Radical to Cultural Feminism, 1969–1975," in *Personal and Political: The Women's Art Movement, 1969–1975*, exh. cat. (East Hampton, N.Y.: Guild Hall Museum, 2002), 29.

3. Ann Powers, quoted in Jennifer Baumgardner and Amy Richards, *Manifesta: Young Women, Feminism, and the Future* (New York: Farrar, Straus, and Giroux, 2000), 134.

4. Yolanda M. López and Moira Roth, "Social Protest: Racism and Sexism," in *The Power of Feminist Art: The American Movement of the 1970s, History and Impact*, ed. Norma Broude and Mary D. Garrard (New York: Harry N. Abrams, 1994), 152.

5. Rineke Dijkstra, in "The Naked Immediacy of Photography" (interview with Claire Bishop), *Flash Art*, no. 203 (November–December 1998): 88.

6. Rineke Dijkstra, interview with Jessica Morgan, in *Portraits: Rineke Dijkstra*, exh. cat. (Boston: Institute of Contemporary Art, in collaboration with Hatje Cantz, 2001), 79.

7. Ibid., 12.

8. See John Slyce, "On Time, Narration, and Performative Realism: The Photographs of Sarah Jones," in *Sarah Jones*, exh. cat. (Essen: Museum Folkwang, 2000), 108.

9. Deborah Solomon, "The Women behind Photography's New Golden Age," *New York Times*, 9 September 2001.

10. I'm indebted here to Taru Elfving's insightful writings about Tykkä.

 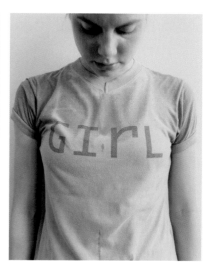

14–16
Salla Tykkä
Sick, 1997
More Sick, 1997
The Sickest One, 1997
Cat. nos. 63–65

GIRL—her identity is spelled out in the text on her T-shirt. But does the bold announcement really reinforce her identity as a girl, or does it actually draw attention to the problems inherent in this identification? The image is the third in a series of three photographs by Salla Tykkä titled *Sick*, *More Sick*, and *The Sickest One* (1997; figs. 14–16). The girl in the picture, the artist herself, seems to be focusing on the text, as if pointing to the cause of her condition. Is this marking as a girl making her sick, even the sickest one of all? A wet stain on her chest disrupts the surface, the veiling of her embodied being in girlness. It draws our eyes to her breasts, which push against the red text. Her body does not seem to fit comfortably into this mask. The text, in its apparent simplicity and factuality, ends up marking a site of rupture.

So what is a Girl? Luce Irigaray's reading of Freud shows how, according to his logic, a Girl never was and never will be: "What has become apparent to him about it, female sexuality can be graphed along the axes of visibility of (so-called) masculine sexuality. For such a demonstration to hold up, the little girl must immediately become a little boy." Therefore the Girl can be imag(in)ed only in relation to the boy and the form given to his body and sexuality. In this comparison she lacks, hasn't got big enough, has nothing to be seen, is invisible. Irigaray claims: "Nothing to be seen is equivalent to having no thing. No being and no truth."[1]

How can one be a no-thing? How can a no-thing be represented? Or become a woman? No wonder Tykkä's girl is (feeling) sick. But there is radical potential in this impossible position. The Girl as a no-thing can be understood as something other than an opposite or a negative, as something that defies the representational logic based on solid entities and sameness.[2] As Gilles Deleuze and Felix Guattari argue, it is the Girl's body that is stolen first "in order to fabricate opposable organisms and to impose a history, or prehistory, upon her."[3] Her being is evacuated of all materiality and meaning. She

17, 18
Rineke Dijkstra
Almerisa, Asylumcenter Leiden, Leiden,
Netherlands, March 14, 1994, 1994
Almerisa, Wormer, Netherlands, June 23, 1996,
1996
Cat. nos. 28, 29

40

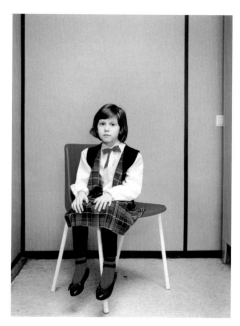

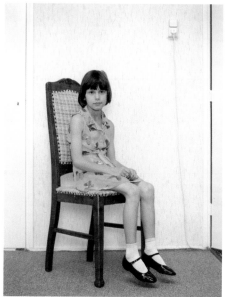

appears as a virgin surface prior to any recognizable form and function. This allows then for further erasure of all matter and difference that cannot be reduced to dichotomies. But her sexuality and subjectivity are therefore also a historically and culturally specific weak hinge in the oppositional order and determined lines of progress.

The Girl poses a threat and has to be silenced under the cloak of pure innocence and light spirit, all things sweet and pink. She is given form by protective prohibitions that draw boundaries around her supposedly vulnerable being—which is not, cannot, should not—covering over her indeterminacy, more or less successfully. Thus the figure of the Girl circulates in contemporary visual culture as a site of constant negotiation and fascination, veiling and unveiling. This is the carefully guarded blind spot that the artists in *Girls' Night Out* also mobilize, albeit with very distinct viewpoints, strategies, and spins. Instead of trying to represent the unrepresentable, they draw our attention to the cracks and ruptures that the Girl creates and inhabits in the field of visibility.

BECOMINGS

Rineke Dijkstra's series of photographs Almerisa (1994–2003; figs. 17, 18, 48, 49, 81, 82) maps the process of growing from a girl into a young woman through images of her subject, a Bosnian refugee, seated in a chair. The girl's feet eventually reach the ground, and her posture achieves gravity. Her pose becomes increasingly considered and carefully composed. Are we witnessing a progress from innocence to awareness and maturity, an entry into the game of representation and assumption of ideals? Or can this series of images be read otherwise, as rupturing the determined line of development? To read this in relation to the move from east to west, which the girl can be seen as embodying, risks once more re-enforcing the hierarchical oppositions

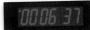

built into linear models, such as that of nature and culture. How can we complicate this timeline and see beyond it?

Kelly Nipper's works draw attention to the complexities of time and its depiction. For her series of photographs Timing Exercises (2001–2; fig. 19), she asked a group of people to close their eyes for what they estimated to be a period of ten minutes. Images of the models with their eyes closed in intense concentration are paired with images of a digital clock revealing the actual duration of the exercise. Do the participants fail to approximate the exact duration, or does clock time prove unsuccessful in grasping the individual's embodied experience of time? The paused moments in these images do not give definite form to fleeting events, but instead mobilize the notion of time. Stillness is here charged with layers of temporality.

The complexity revealed in the attempt to make time visible can be applied to the notions of "girlness" and "teenage" as well. The teen years are generally understood as a confusing state in between. The Girl's changing body becomes marked by culture with tropes of femininity, female sexuality, and reproductive function, and she becomes increasingly aware of this marking. This notion of an intermediate stage in a linear, supposedly natural development is both reinforced and challenged in contemporary art. The notable interest in the teenager, and in different aspects of youth culture in general, in recent art may reflect not only nostalgia for this tempestuous transitional period but also recognition of the radical indeterminacy that this life stage embodies.

The photographs of Sarah Jones often focus on the charge created by the presence of teenage girls. In her series Francis Place (1997–99; figs. 60, 61, 63), three girls, shown singly or in various groupings, seem to be suspended in the timeless space of their homes, which are steeped in family heritage, wealth, and conservatism. The suffocating, and possibly explosive, tension in the images is palpable.

19
Kelly Nipper
Timing Exercise 6:37, 2001–2
Two framed chromogenic prints
37 1/2 x 47 1/2 in. (95.2 x 120.6 cm) each
Courtesy galleria francesca kaufmann, Milan

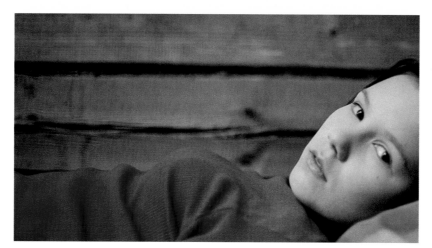

42

Are the girls forever bound to this frozen moment? Or do they embody forces that cannot be suppressed by this eternal order of tradition, where the future is determined by the past? The subjects here emphasize the disruptive power attributed to the teenager, the moment before they are to follow the example of the woman in a framed portrait who appears to be keeping an eye on them in the dining room. In the model of progression the Girl can be represented only as a to-be-woman, a not-yet. In this economy she has to lose something in order to gain something else. But what can a no-thing possibly lose? Does loss of innocence actually mean loss of openness, a closure? Can this charge surrounding Jones's girls ever really be exhausted, become framed and fixed into another portrait above a mantel?

Tykkä's video work *Thriller* (2001; figs. 20, 79) is the second part in a trilogy that explores the intensities embodied by a young female subject. Tykkä strips to the very basics the cinematic genres of spaghetti western, horror, and science fiction, subtly confusing all expected orders and oppositions. Complicating clear timelines on numerous levels, the works in this trilogy leap from young womanhood back to teenage and then off to the future. In *Thriller* we encounter a girl, who seems to embody awakening sexuality. She stands out from the somber surroundings of her home in a bright red shirt, through which she tentatively feels her body. In the end she picks up a gun, and the work climaxes in a shot. We are left with a chillingly peaceful image of a sheep that blends into gray patches of snow stained by a few red splashes.

Tykkä's girl ritualistically crosses the line from childhood to the sexual subjectivity of an adult. Or does she? Maybe teenage is actually revealed here to be given form by rituals, which cover over the complexity of its drama. Are we really witnessing a transformation? Or a violent refusal of its irreversibility? Does she leave her no-thingness

behind? The Girl may persist in her, as unmarked, which according to Peggy Phelan is: "a configuration of subjectivity which exceeds, even while informing, both the gaze and language."[4] Something remains always unmarked by the boundaries and veils drawn around the Girl and keeps haunting these visual and textual frames that attempt to capture her. The Girl as unmarked is inseparable from the markers of girlhood, yet never reduced to them completely. The Girl persists in the girliest of girls, disrupting the otherwise unquestioned significations projected onto this girlness. Tykkä's girl also escapes from the determining grip of the ritual. The clichéd innocence of the sacrificed sheep appears rather impure in this world of grayish white.

RUPTURES

Processes of transition, and particularly the failure to attain the ideal, resonate with memories of shame and disappointment. In her video *Lesson* (1998; fig. 28), Elina Brotherus presents an experience painfully recognizable to many of us. The artist's thin body is veiled in a shiny striped gymnastics suit, which recalls childhood in the 1980s. She clumsily follows the ballet instructions given by a high-pitched female voice. The abusive criticism of her performance leaks a hint of suffocated laughter, and Brotherus's deadpan mask slips a little. The power of this work lies not in irony, but in the ability of a young adult to find humor in experiences that have scarred many during their girlhood years.

Dijkstra's *Buzzclub, Liverpool, England / Mysteryworld, Zaandam, Netherlands* (1996–97; fig. 27) urges us also to reach beyond initial embarrassment and defensive laughter when faced with the clash between the ideal and the embodied beings of teenage girls. The girls dance alone against a white background, their hesitant moves and the cheap glamour of their dresses creating an air of nearly unbearable

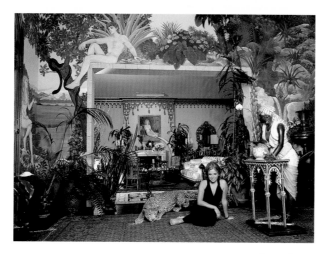

21
Daniela Rossell
Untitled (Ricas y famosas), 2002
C-print, edition of 5
30 x 40 in. (76.2 x 101.6 cm)
Courtesy Greene Naftali, Inc., New York

44

awkwardness around them. As with the dancer in Brotherus's work, the girls' vain attempts to embody perfection emphasize something unmarked that is never swallowed completely by the pose of femininity—nor that of masculinity either, for that matter.

Katy Grannan's portraits of women also reveal the subtle failures of her subjects to become the desired images. The artist frames the poses chosen by the models with a sharp yet never unsympathetic eye. She captures charged moments of slippage, where the pictures become haunted by some unimag(in)able presence. Grannan's models do not quite succeed in fulfilling the ideals that the women in Daniela Rossell's photographs supposedly embody—for example, in the series *Ricas y famosas* (1994–; fig. 21). The immaculately groomed, toned, and composed young women are surrounded by interiors and objects that all scream opulence. Inseparable from their environments, the figures become material icons of desire and seduction, outstripping even the most extravagant late-twentieth-century Hollywood dreams. In Rossell's images, however, this success leads to a sense of extreme artificiality. Do the women actually differ that much from girls playing princesses? Where is the line between masquerade of femininity and childhood authenticity?

Whether unintentional or carefully considered, failure carries with it a grain of resistance, a power to rupture. Poses out of sync, steps out of line, reveal something that does not quite fit. Maybe the Girl never fully, successfully, becomes a woman? Her no-thingness keeps jamming the machines of representation and creating openings to thresholds. She is "a fugitive being," as Gilles Deleuze and Felix Guattari put it. "Thus girls do not belong to an age group, sex, order or kingdom: they slip in everywhere, between orders, acts, ages, sexes."[5] Everywhere and nowhere, in constant flight.

In Preparation for Flight (2001; fig. 22), a photograph by Dorit Cypis, hints at a fascination with thresholds that obscure boundaries

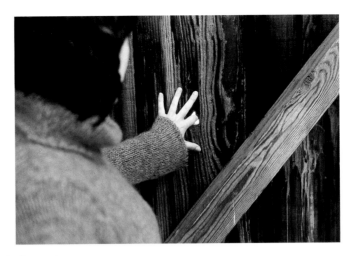

22
Dorit Cypis
In Preparation for Flight, 2001
Cat. no. 18

and allow for takeoffs. Facing away from us, a female figure (a woman, a girl?) in a red sweater pushes her finger through a hole in a fence. In many of Cypis's images we encounter spatial divisions, portals, and layers of reflection. Through the looking glass, we enter into a peculiar order of things, where in and out, back and front, lose clear reference points. As Alice has proven, here little girls grow smaller and larger for whatever reason, and doorways can lead to all kinds of directions. In Cypis's picture *The Rest in Motion 2* (2002; fig. 12), a curtain attempts to fly out of an open window. Pushing over this border, it gains bodily, yet simultaneously ghostly, substance. The outside, or behind, of the curtain becomes the inside of the curtain-body in its flight. This (dis)embodied presence haunts the threshold, like the Girl—formless form, invisible visibility, (like) a ghost.[6]

THRESHOLDS

Representation of the Girl's embodied being as a blank page, which assumes form and meaning only during the teenage years, gives free reign for forces of evil to occupy her as their disguise. This places her in need of protection by constantly reinforced boundaries that aim to cover over her own ghostliness. When marked as a teenager by all the contradictions of femininity and female sexuality, she remains a material vessel—either nursing mother or devouring flesh, vagina dentata. How could an unmarked possibly be contained in these envelopes and the numerous borders? Could the borderline stage that is teenage, as well as all other boundaries, be reimagined in terms of thresholds? Rather than an in-between and a line to be crossed, *threshold* suggests a dynamic point of collision, where subjectivities and differences are continually negotiated.

This realm of the threshold(s) may be that which Alice explores, according to Teresa de Lauretis: "The Looking-Glass world

●● 46

which the brave and sensible Alice enters, refusing to be caught up in her own reflection on the mantelpiece, is not a place of symmetrical reversal, of anti-matter, or a mirror-image inversion of the one she comes from. It is the world of discourse and of asymmetry, whose arbitrary rules work to displace the subject, Alice, from any possibility of naturalistic identification."[7] In this world of constant negotiation, preconceptions and truths based on oppositions cease to function, revealing their absurdity. Here we may encounter the Girl and all that persists as unmarked. Is this the world that the artists in *Girls' Night Out* hint at in their individual quests to give appearance to something that defies the conventions of representation?

Shirana Shahbazi tempts us to this ambiguous area in her intense yet fragmentary installations of photographs from the series *Goftare Nik / Good Words* (2000–2003; fig. 23). Following her, we get glimpses of Iranian contemporary everyday in all its ordinariness, but viewed from a threshold, neither from inside nor from outside of national or cultural borders, private or public spheres. Staged moments could be lucky snapshots, and vice versa. Shahbazi's images tell a thousand and one stories, veiling and unveiling, until the (often gendered) tropes and codes of cultural difference can no longer maintain a solid footing. Vast landscapes and cityscapes resist any attempt to locate them, just as the many images of women do: a young girl on Rollerblades, a bride in white posing under a blooming tree, a mother veiled in black tying the shoelaces of a young boy on the street, a rather blasé young woman smoking a cigarette, her running shoes in happy marriage with her head scarf. What is Shahbazi really unveiling here? Does the act of revealing become a re-veiling?

In Eija-Liisa Ahtila's video installation *Lahja—The Present* (2001–2; fig. 24), the characters take us to the fine, murky line between normal and unbalanced. Conflating stories of women's actual experiences of psychosis with imagined ones, Ahtila presents five

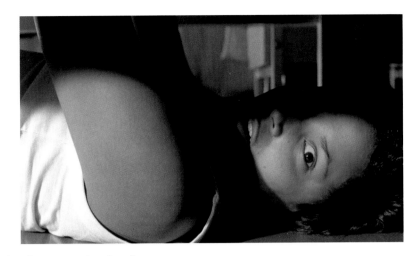

24
Eija-Liisa Ahtila
Still from *Lahja—The Present*, 2001
Cat. no. 1

individual narratives that challenge the borders separating fact from fiction and sanity from insanity. Like Shahbazi, she dares us to look through the surface layers of the visible. Language reveals its limitations here in comparison with the visual as we try to articulate these borderline cases. Reverting to presumably transparent terms such as *documentary* and *fiction*, we end up framing these thresholds again as in-betweens. There are no suitable names for something that not only opens into an either/or direction but actually sets these opposites into motion as well.

Ahtila's characters are neither victims nor visionaries. They defy acceptable norms and find unusual solutions to their troubles. One turns the order upside down in her room (in "The Wind"), while another (in "The House") blocks out all visual stimuli with black curtains so as to be where the sounds in her head are. One crawls over a bridge (in "The Bridge), while another hides under her bed (in "Underworld"). The women are joined by a teenage girl (in "Ground Control"), who lies down, saintlike, in a puddle of muddy water in the yard of her home. Wouldn't this all be somewhat understandable, even if not acceptable, for a young girl? Is the defiant girl there, behind the veil of adult femininity, suppressed and now causing grief? "Give yourself a present, forgive yourself," announces a text in the end of each short story. Forgive what? No-thingness? To quote the female character in "The Bridge": "I realized I looked mad. That that's where the madness is." Visible can be defined. Only then is the border crossed. But what is left unseen, unmarked?

The Girl lives on in us, but not necessarily as a lamentable memory of lost virginity and purity that haunts us forever. Instead her presence can remind us of all that has not been suffocated within the frame of ideal femininity. It can be liberating, exhilarating even, as with the laughter provoked in Brotherus's video. In her photographic work Brotherus takes the leading role in various settings that evoke

different genres of painting. The pictures are often like stills from a narrative, but here the actress fails to act, to strike a convincing pose. Her stubborn presence defies the demand to become (part of) a picture. Defiance does not need to be seen here as childish and doomed to surrender in the face of reason. Girlish sulking, refusal to assume a pose at the right time and in the manner expected, is where the veil of innocence is fractured, possibly even providing a glimpse of the unknown, the indeterminate.

The defiant gazes that we encounter in many of the works discussed here do not reveal the monstrous feminine or some intruding alien.[8] From the bored young ladies in Jones's photographs to the intense muteness of the girl in *Thriller*, we meet silent resistance that ruptures our expectation and desire to capture the girls in images of pure yet sensual beauty. They stare back at us, or sometimes spare us only a quick glance, teasing but revealing nothing. Irreducible to the form given to the female body and sexuality, the Girl, the unmarked, cannot be named or occupied. What happens when she looks back? Or when we enter the threshold of the (in)visible? What if I choose to wear that T-shirt and be(come) a Girl?

NOTES

1. Luce Irigaray, *Speculum of the Other Woman*, trans. Gillian G. Gill (Ithaca, N.Y.: Cornell University Press, 1985), 48.

2. This refers to, among others things, Irigaray's notion of the logic of the same, which describes the workings of the binary logic that defines everything in terms of oppositions, thus excluding all irreducible difference. See Luce Irigaray, *This Sex Which Is Not One*, trans. Catherine Porter (Ithaca, N.Y.: Cornell University Press, 1985).

3. Gilles Deleuze and Felix Guattari, *A Thousand Plateaus: Capitalism and Schizophrenia* (London: Athlone, 1988), 276.

4. Peggy Phelan, *Unmarked: The Politics of Performance* (London and New York: Routledge, 1993), 27.

5. Deleuze and Guattari, *A Thousand Plateaus*, 271, 277.

6. The ghost here refers specifically to Derrida's notion of the specter and the radical challenge it poses to all solid structures and dichotomies. See Jacques Derrida, *Specters of Marx: The State of the Debt, the Work of Mourning, and the New International*, trans. Peggy Kamuf (London and New York: Routledge, 1994).

7. Teresa de Lauretis, *Alice Doesn't: Feminism, Semiotics, Cinema* (Bloomington: Indiana University Press, 1984), 2.

8. "Monstrous feminine" refers here to figures of female monsters as well as more generally to the notion of female embodied subjectivity as unbounded and incomprehensible, an antithesis of masculine rationality which threatens and has to be kept in check. This is discussed by Barbara Creed in relation to horror films in *The Monstrous-Feminine: Film, Feminism, Psychoanalysis* (New York and London: Routledge, 1993). Creed also examines the theme of possession in relation to figures of girls in horror films, as does Carol C. Clover, in *Men, Women, and Chain Saws: Gender in the Modern Horror Film* (Princeton, N.J.: Princeton University Press, 1992).

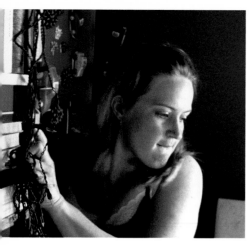

25
Eija-Liisa Ahtila
Stills from *Lahja—The Present*, 2001
Cat. no. 1

Bill Horrigan

MOVING

Ten years ago, an exhibition entitled *The First Generation: Women and Video, 1970–75* began a two-year transcontinental tour, acquainting viewers with the pioneering role twenty-one female artists had played in exploring the then-vanguard genre of video, a supple medium with an accessible technology evolving coincident with feminist art practices. The impetus driving this exhibition was frankly corrective, aimed at contributing research and restoring perishable artifacts for contemporary art history; as one of the catalogue essayists, Ann-Sargent Wooster, pointed out, "These videotapes by women are the fulcrum between modernism and postmodernism"[1]—one world semaphoring to another.

Out of willfulness, one could imagine a historical survey of video of the same period that pointedly excluded women, but the odd paucity of the result would do little other than to embed more firmly the significance to contemporary art of these first-generation female video artists. Similar in key but certainly not all respects to feminist film of the time (crucial differences having to do with video's unique relationship to the gallery system, which is to say, with their respective networks of distribution, exhibition, and reception), early video by women challenged representations of sexuality and gender, interrogated the spheres of domesticity and the everyday, and asserted female subjectivity as legitimate. That said, the artists in *The First Generation* were astonishingly heterogeneous, ranging from documentarians such as Julie Gustafson; to multimedia artists such as Beryl Korot, Joan Jonas, and Mary Lucier; to experimental pioneers Steina and Barbara Buckner; to Conceptualists such as Martha Rosler and Lisa Steele.

There is a tough-minded logic behind exhibitions determined to restore moments or individuals to art history's master narratives, but in the case of *The First Generation*, that intent registered in a complex and poignant fashion, because by 1993, and in the subsequent years of its itinerary, it had become clear that "video," in the relatively coherent

form identified in the exhibition, had for all intents ceased to exist. Or, rather, video had become a single element within the overarching spectacle of moving images in the gallery (e.g., computer-assisted works and Web projects that arrogated video's once-defining "live" qualities and multimedia sculptural installations using video as one of multiple material constituents), and the reterritorialization of art instated by the triumph of the moving image had, by the 1990s, been drawing inspiration from cinema as much as from anything else—as much, that is, as from the realm of video art.

Cinema's migration into the gallery, roughly coinciding with its centenary, was crucially brokered by advances in digital image production and, more importantly, by superior projection technologies, which, by definitively liberating moving images from the confines of the monitor, enlisted them into the historically superior realm of projection—one of the cinema's defining conditions both socially and affectively. But it could be argued that in themselves those are nothing more than extensions of the artisanal and programmatic tools used over the past forty years by moving-image–based artists. That in turn is a way of suggesting that cinema's present gallery habitation finally exceeds the shared condition of projected images but instead refers to—invokes, channels, absorbs—the formal language (and its popular vernaculars) by which the movies tell us stories.

In *Girls' Night Out*, the moving image avails itself of varied delivery systems, from single- and multiple-monitor based to single and multiple projections, with the specific configurations determining the scale and proximity of the image relative to the viewer's mobile, sentient body. But if the exhibition's moving-image works resist presentational conformity—with the specific range extending from single-channel monitor presentation (Elina Brotherus), to multichannel monitors (Eija-Liisa Ahtila), to single projections (Salla Tykkä), to multi-image projections (Rineke Dijkstra, Kelly Nipper)—that dispersal of the device is counterweighed by the

coherence the works share as cinematic parables describing incidents from the lives of young women. When I refer to the "coherence" of these works, I do not mean to suggest a uniformity of tone or mode of rhetorical address, but rather to note the passion the artists share for reviving and refiguring incidents from the lives of women, from girlhood to young adulthood, through clarifying and puzzling scenarios. While the complexity of the artists' means (on the levels both of image production and of the specific viewing apparatuses constructed in the gallery) belies the thought that they could regard moving-image creation as transparent, the stress in these works falls, nonetheless, on the primacy of the stories the artists are compelled to recount.

These shared concerns are set in the context of what one critic recently called "the new feminist film ecosystem,"[2] referring to, among other things, the dramatic reconfiguration over the past decade of a once-visible and coherent feminist filmmaking enterprise confronting an academy and a marketplace regulated by festivals and distributors more supportive of works with postcolonial, queer, and multicultural perspectives than of those with "feminist" ones. Yet that ecosystem, on the level of exhibition, increasingly counts the gallery as one of its sustaining environments, as the moving-image works in *Girls' Night Out* demonstrate. The variety of expression and intent in *The First Generation* makes it difficult to present a meaningful assessment of the commonalities among the artists. An attempt to summarily contain feminist-inflected moving-image making as presently practiced would be equally frustrating. Despite sharing certain artistic thematic preoccupations—specifically, registering, imagining, and rehearsing routines in the inner lives of young women—the moving-image artists in *Girls' Night Out* correspond to points widely spaced across a cinematic spectrum.

Nuance, hybrid, and genius aside, orthodox film studies long distinguished among three principal expressive modes: fiction,

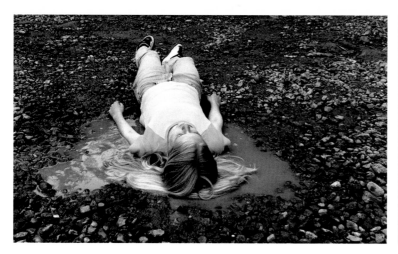 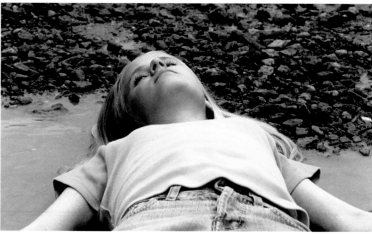

26
Eija-Liisa Ahtila
Stills from *Lahja—The Present*, 2001
Cat. no. 1

documentary, and experimental (or "avant-garde"). Each of these can be said to differ based on how it apprehends and conveys cinema's thrall to photographed reality and on the nature of the disinterested surrender a work obliges its spectators to make for the period of its duration. (As André Bazin stated, "Viewed in this perspective, the cinema is objectivity in time.")[3]

As is evident in the moving-image works in *Girls' Night Out*, these three major modes and the corresponding disposition a viewer is cued to assume while watching a single work play itself out—taking the measure, that is, of a work's relation to the photographic reality it has now visibly and aurally reordered for secondary poetic construction—are in turn inflected by their transit from a cinema-based model to a gallery situation in which viewpoint dependency is generally not mandated. (A gallery posting a "screening schedule" for a time-based work's viewing typically redounds to its discredit.) Instead, it's precisely the legacy of avant-garde film, with its tradition of interrogating and rearranging the in-built stabilities of commercial cinema (hidden projector, fixed seating, ticketed admission, and so on) that now informs the presence of moving-image works in the gallery, despite the fact that it's less often a canonical "avant-garde" that such works invoke than it is the immensity of cinema in its guise as mass medium, the aggregate of its stories and syntaxes as globally practiced and understood.

Eija-Liisa Ahtila's work is grounded in the deceptively blank veneer of contemporary domestic Western reality, and to that extent it's idiomatically of a piece with more conventional media. But in *Lahja—The Present*'s five short stories (as in 1999's daunting two-screen *Consolation Service*), initial assurances of familiarity are sharply undermined as the artist visualizes the assault of psychosis on the bodies of girls and women. Light-handed yet steely bizarre, *The Present* (2001–2; fig. 26) has a double life as a gallery installation and as a series of television public service announcements (PSAs) on

Rineke Dijkstra
Stills from *The Buzzclub, Liverpool, England / Mysteryworld, Zaandam, Netherlands*, 1996–97
Cat. no. 34

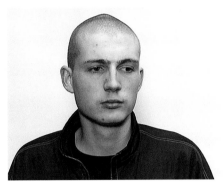

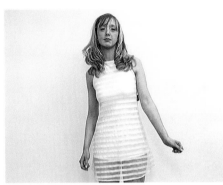

the theme of empathy, and while it's not unheard of for PSAs to support ideas related to subjectivity over citizenship or partisanship, Ahtila's brief stories remarkably evoke cinematic precedents, ranging from Lillian Gish being traumatized in *The Wind* (1928) to the anguished women in modernist cinema in the Bergman mode, to the mad housewives of postwar fiction, advertising, and commercial film and television (the latter sometimes subjected to such cinematic "special effects" as shrinking, visual metaphors Ahtila also deploys).

Like Ahtila, Rineke Dijkstra tends to stay behind, not in front of, her camera; also like such video pioneers as Julie Gustafson, she avows a *vérité* approach in pursuit of the intimacies of identity, although without opening the Pandora's box of having her subjects actually speak. In *The Buzzclub, Liverpool, England / Mysteryworld, Zaandam, Netherlands* (1996–97; fig. 27), she simply encouraged teenage kids to respond to the thumping disco-techno beat being pumped out elsewhere in the club, off camera. Using a static frame and minimal edits, Dijkstra brings to her project the eye of an ethnographer, albeit one adjusting for empathy and curiosity, and she grants to her subjects the luxury of real-time, extended duration, a bequest perforce unavailable in her still-photographic endeavors. Like her compatriot Johan van der Keuken's 1955 photo book, *We Are Seventeen* (a landmark publication in the annals of Dutch photography and of national visual consciousness, by an artist who would go on to become one of the great documentary portraitists of the late twentieth century), *Buzzclub* is an uncanny capture of teenage self-possession.

A characteristic effect of Elina Brotherus's work is the sense that the artist is simultaneously presenting and absenting herself during the transaction of self-portraiture, the almost Rimbaudian sleight of "je est un[e] autre." Although technically depicting the artist being addressed by her dance instructor, *Lesson* (1998; fig. 28) shares little ground with the venerable "choreography for the camera" film genre, with Brotherus's camera here enlisted to record the testament of

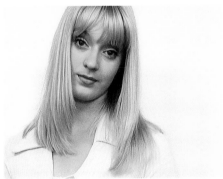

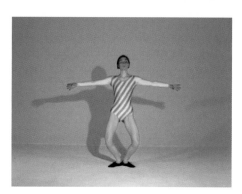

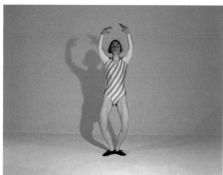

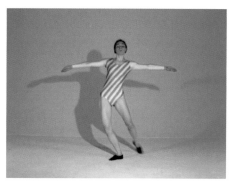

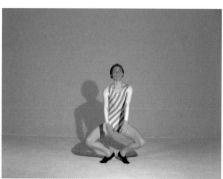

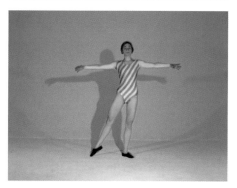

her own shortcomings. It's an unforgiving, dogged account, the artist's native language and proficiency at odds with the exacting traditions the instructor upholds. Ponder how seldom it is that one sees failure distilled into a form neither heroic nor comic.

Salla Tykkä's short films are as disorienting as some of Ahtila's, but she describes them in strongly autobiographical terms; if they are not faithful to the facts of her own life, they nevertheless reflect her emotional landscape and its signal anxieties. Buñuel-like puzzlement prevails in *Thriller* (2001; fig. 29), a seamlessly produced short in which the characters' ambiguous interrelationships are further confounded by the sound track's sampling of the theme from John Carpenter's persistently influential horror film *Halloween* (1978). Less menacingly, *Lasso* (2000; figs. 77, 78) invokes Ennio Morricone's theme from *Once upon a Time in the West* (1968) to underscore the distraught young woman's sensations as she peers through the windows of a house (her own?) to spy on a bare-chested young man engaged in a virtuosic (if mistakenly solitary) bout of rope twirling.

Tykkä's linkage of her own work to that of mainstream moviemaking via her sound-track appropriations is underscored by the transparent classicism of her filmmaking style; again, like Ahtila's, this work is as imaginable in the cinema as in the gallery. While Kelly Nipper's *Bending Water into a Heart Shape* (2003; fig. 66) partakes in some of its components of the Structural Film heritage—the palpable rendering and repetition of empty space, for example, and the rigorous fidelity to recording the performer executing movement in real time (ironically, a movement slowed down in its actual execution rather than as a postproduction editing effect)—it is a complex artwork that deploys cinema simply as one of its constituent informing influences and requires extra-cinematic, three-dimensional strategies (principally, a large mobile in the gallery) for its full realization.

That said, it's the sculptural complement of film and video viewing apparatuses enlisted to "hold" *Girls' Night Out*'s moving-image

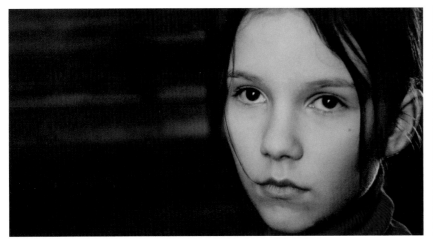
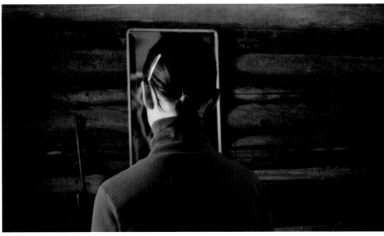

works that mirrors—runs side by side with—the range of lyrical modes (from "experimental" to "documentary" to "fiction") the exhibition summarily expresses. The forays and labors of several generations of "video artists" (now an appellation already historicized) precede and figuratively authorize the moving-image works in *Girls' Night Out*, but enveloping them remains the drifting shadow of global cinema, a shadow above, below, and beyond but one that periodically clears a space for the uncertainties of identity and for the artist's hard eye (foraging, cleansing, leveling) to coinhabit.

29
Salla Tykkä
Stills from *Thriller*, 2001
Cat. no. 67

NOTES

1. Ann-Sargent Wooster, "The Way We Were," in *The First Generation: Women and Video, 1970–75*, exh. cat. (New York: Independent Curators Incorporated, 1993), 21.
2. Patricia R. Zimmerman, "Feminist Film and the Ivory Tower," *Independent Film and Video Monthly* 26 (March 2003): 50.
3. André Bazin, "The Ontology of the Photographic Image," in *What Is Cinema?* (Berkeley and Los Angeles: University of California Press, 1967), 14.

THE ARTISTS

Irene Hofmann

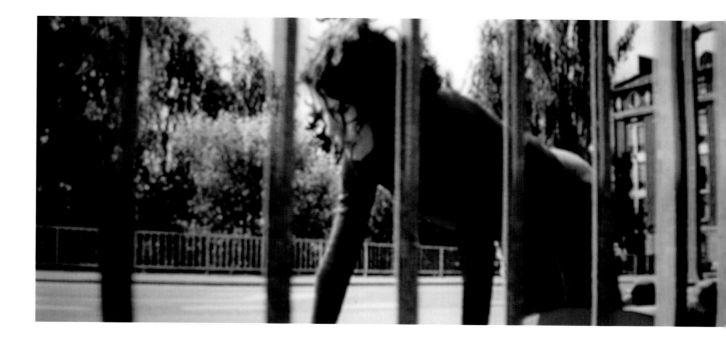

30
Eija-Liisa Ahtila
Still from *Lahja—The Present*, 2001
Cat. no. 1

In Eija-Liisa Ahtila's works, ordinary people are caught up in the more troubling aspects of their personal lives: a couple's marriage breaks up, an adolescent girl rebels against her mother, a young woman struggles with the debilitating effects of a mental illness. Working with moving images in the form of multichannel video installations, thirty-five-millimeter films, and broadcast television spots, Ahtila is an accomplished and poetic storyteller, skillfully manipulating, contradicting, and often dismantling the conventions of cinema, linear narrative, and authorial position. With stories based on both real and fictive incidents, Ahtila's arresting works are what she calls "human dramas," often posing existential questions and introducing fragile, flawed, and vulnerable characters who are presented as individuals yet embody universal dilemmas.

Addressing identity, adolescence, and sexuality, Ahtila's early film *If 6 Was 9* (1995; fig. 31) introduces a group of young girls on the verge of womanhood and sexual awakening. Named after a defiant Jimi Hendrix song, and shown as both a ten-minute thirty-five-millimeter film and a three-channel video projection installation, *If 6 Was 9* features five young Helsinki girls, ages thirteen to fifteen, hanging out and sharing stories about their sexual fantasies, curiosities, and experiences. With a tone reminiscent of the "confessional" booth on MTV's *Real World* and other reality TV shows, the girls frankly discuss looking at porn magazines, playing doctor, and other early sexual experiences. What seems like a candid and revealing documentary, however, becomes disrupted halfway through the film as one of the girls begins to speak as an adult woman, claiming to be thirty-eight years old. With the realization that this girl has taken on an unexpected and possibly scripted point of view come additional questions about the authenticity of any of the stories told by the teenagers. *If 6 Was 9* becomes further complicated by Ahtila's expert visual fragmentation of the narrative. Although the work is united by a single sound track, the activity jumps and alternates between three screens,

manipulating the logic of a linear structure while evoking the confusion and uncertainty of adolescence itself.

Further exploiting traditional narrative devices is Ahtila's critically acclaimed heart-wrenching drama of a young couple's separation, entitled *Consolation Service* (1999). This story picks up in a counselor's office as the tormented pair come to terms with the fact that their marriage has fallen apart and is now over. As the couple's neighbor, who serves as the narrator of the story, explains, "It's a story about an ending." Although Ahtila's characters speak Finnish, a language that may be foreign to many viewers, the emotions of their exchanges are familiar as the counselor asks the couple to express their anger and reflect on their mutual history. The work is presented as a two-screen installation; the right-hand screen follows the sequence of the narrative most closely, while the left-hand screen is used to break away to explore details and other subtexts of the couple's story. From the counselor's office the narrative picks up on a partially frozen lake as the couple and their friends fall through a crack in the ice in a surreal sequence that, as Ahtila explains, "became a metaphor for the ending."[1] In the final segment the young woman appears alone in her apartment as she is visited by visions of her presumably drowned spouse. In a touching choreography of bows, the once angry and exasperated couple now seem to honor each other in a gesture of acceptance, farewell, and "consolation."

Ahtila explores the dark and troubling effects of psychological traumas, psychoses, and mental breakdowns in *Lahja—The Present* (2001–2; figs. 30, 32–35), a suite of five related narratives recounted by young women actors. Based on interviews with women suffering from various mental illnesses, these fictional two-minute videos (each taken from a longer work) give cinematic form to disquieting episodes of madness, evoking hallucinations, phobias, and obsessions. In "Underworld," a frightened woman deftly hides under a

31
Eija-Liisa Ahtila
Installation view of *If 6 Was 9*, 1995–96
35mm film on video
10 min.
Courtesy Klemens Gasser & Tanja Grunert, New York

32
Eija-Liisa Ahtila
Installation view of *Lahja—The Present*, 2001
Cat. no. 1

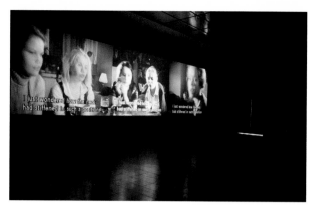

hospital bed from the nursing staff, whom she fears have come to kill her. In "Ground Control," a teenage girl approaches her house, and rather than enter to face her mother inside, she turns away and lies down in a muddy puddle. In "The Bridge," a young mother crawls on hands and knees over a busy city bridge as she describes the nature of her madness. In "The Wind," a woman, unable to shout or express her anger, bites her arms and hands until her rage takes the form of a violent windstorm in her apartment. In "The House," a woman covers all the windows in her house with black curtains to block out the light, allowing her to focus more clearly on the voices she hears in her head.

The Present is shown on five television monitors arranged in a gallery space, with two of the videos playing at any given time, as voices and images overlap, collide, and surround viewers. Like the slips in perception and reality that are experienced by Ahtila's protagonists, her presentation of their stories itself becomes a metaphor for their altered realities. In addition to the gallery installation, *The Present* also takes the form of five thirty-second TV spots intended for broadcast on a television station in the city where the installation is being shown. Like mysterious public service announcements, these spots synopsize *The Present*'s five narratives and are followed by the inspirational phrase "Give yourself a present, forgive yourself." Although *The Present*'s short segments and even shorter TV spots are brief, they are some of Ahtila's most powerful and enduring images of women. Despite the effects of their individual phobias and psychoses, Ahtila writes: "All of the women in *The Present* are doing something, they create their worlds and lives, they are in charge. They don't just lie in bed but take action even when they fall ill."[2] With its altered narrative and cinematic structures, *The Present* offers a rich and multidimensional experience that tells five poignant stories that are at once enigmatic, disorienting, and inspirational.

NOTES

1. Eija-Liisa Ahtila, interviewed in *Coutts Contemporary Art Awards* 2000 (Zurich: Coutts Contemporary Art Foundation, 2000), 17.
2. Eija-Liisa Ahtila, in Samantha Ellis, "Eija-Liisa Ahtila," *Make*, no. 92 (2002): 50.

Eija-Liisa Ahtila
Still from *Lahja—The Present*, 2001
Cat. no. 1

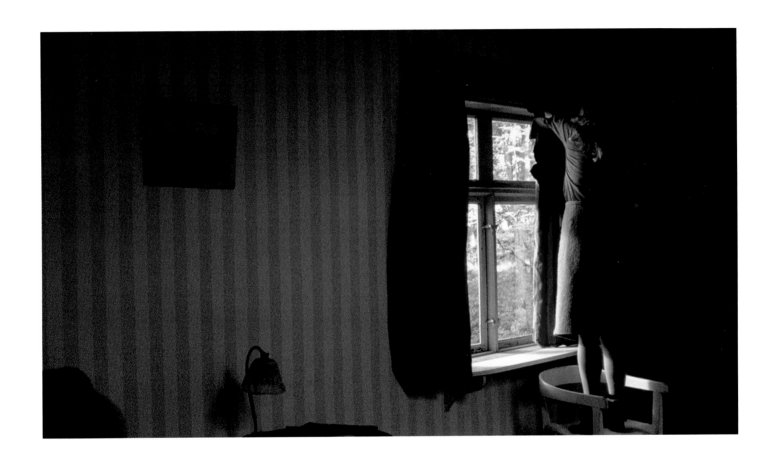

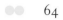

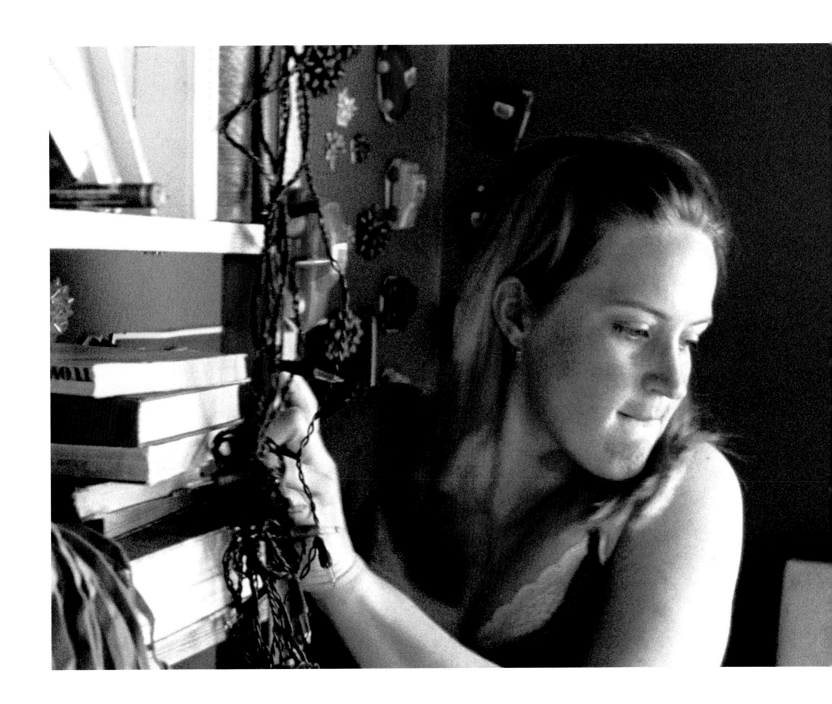

36
Elina Brotherus
Chalon-sur-Saône 6, 1999
Cat. no. 6

Elina Brotherus's works are characterized by their sincere and straightforward treatment of her life as subject matter. Ruthless in her self-portrayal but stopping short of irony and self-deprecation, Brotherus engages issues of gender, the gaze, and formalism in very honest and provocative ways. Playful and drop-dead serious, harsh and tenderly innocent, her brutal self-observation is both a pretext and an end in itself.

The thrust behind her drive for self-representation—strong emotions, intense psychological states, and angst—combined with a severe formalism in her use of light, editing, and printing, makes Brotherus's work complex, beautiful, and compelling. This dynamic relationship between art making, life, and formalism suggests not a practice that seeks to blur their divides but rather one in which lived experience is a precondition for knowledge.

In her first solo show—in Umeå, Sweden, in 1998—which included works from two series, entitled Das Mädchen sprach von Liebe and Self-Portraits, Brotherus's work already reflected ongoing research in the medium of photography, particularly as it lends itself to self-observation, given the lag between the taking of the photographs and the viewing of the result. The temporal dimension gives the artist the distance to engage in personal inquiry without indulgence. This could account for the treatment of loaded biographical experiences without any sense of victimization or irony. Whether portraying herself in the clothing of her parents after their deaths or capturing the emotions of her failed marriage, Brotherus resolves the potential ensuing drama by treating the subject simply and directly in what she calls an "emotional landscape." She explains: "When life is shaky, I get the urge and passion to make photographs. . . . In every person's life there are both large and small tragedies, much and little happiness; there are emotions and needs. That is why fragments from my life might seem familiar to others as well."[1]

A residency in Chalon-sur-Saône, France, in 1999 led to Brotherus's next two series of images, Suites françaises 1 and 2. In Suites françaises 1, moody cityscapes entered into her work as she explored the French urban landscape by night. Highly formal works such as *Marseille* and *Chalon-sur-Saône 6* (1999; fig. 36) are noticeably devoid of human presence and marked by painterly colors and dramatic deep perspectives.[2] The companion to this series, Suites françaises 2, returns to self-portraiture with works that poignantly explore the artist's loneliness and isolation as a newcomer to a country whose language was foreign to her. This series of images centers around the small, spartan dorm room where Brotherus lived during her residency. Post-it notes with words and phrases placed on objects and people in her room are a humorous and touching attempt to understand a new language and an unfamiliar environment. The first image in this series, titled *Revenue* (1999; fig. 41), shows Brotherus on the day of her arrival, with her coat, gloves, and backpack still on and her packed suitcase at her side. She is visibly exhausted and perhaps even dazed by the strange surroundings that she has already begun to label with small yellow notes. Later in the series, we find Brotherus curled up in a chair surrounded by the clutter of her new life (fig. 37). With objects and Post-it notes all around her, a note attached to her chest defiantly asks, "Contente enfin?" (Are you happy now?).

The heartfelt emotion and brutal honesty of such self-portraits have much to do with Brotherus's relationship to the camera and its constant presence in her life. Always having the camera accessible and often ready on a tripod in the corner of her room, she explains, allows her to better recognize and respond to what she calls "decisive moments."[3] As viewers of these charged and personal moments, we too are made aware of the camera since in many of these images Brotherus makes no attempt to hide the shutter release cable. Not only do we become keenly aware of the camera's presence

37
Elina Brotherus
Contente enfin? 1999
Cat. no. 7

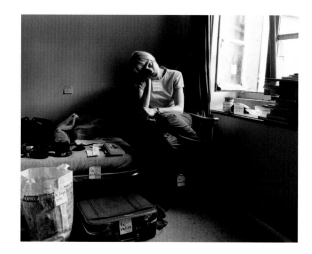

through this apparatus, but it also suggests her solitude in the space and reinforces the sense that she is letting us in on a very private moment.

In her most recent body of work, entitled The New Painting (2000–), Brotherus moves freely between portraiture and landscape, two genres that she has always found to be interrelated. As she writes, "Where self-portraits are windows into myself, landscapes are windows opening outward from me."4 With tongue-in-cheek titles such as *L'artiste et son modèle*, *Les baigneurs*, and *Femme à sa toilette* (fig. 40), she references the history of painting in images that continue her aesthetic inquiry into traditional formalism: light, color, composition, figures, and spatiality. In contrast to her earlier work, much of the narrative element has been depleted from these recent works. This strategy is key insofar as it allows the artist to depict herself as a model without the overt references and weight that are inherent in self-portraiture. The landscapes from this series focus on the horizon as a subject and a means of exploring color, form, and abstraction (see fig. 38). Embedded with poetic qualities and quite painterly, many of these landscapes recall those of German Romantic Caspar David Friedrich (1774–1840) and Nordic genre painters. These works evoke the word *ensouled*, the term Walter Benjamin used to refer to lyrical, psychological, or spiritual states projected onto nature.

Whether depicting her own deep emotions, milestones in her life, or the landscapes of her surroundings, Elina Brotherus bravely confronts her life and her image in remarkable ways, producing works of extraordinary honesty and beauty that touch on universal themes.

NOTES
1. Elina Brotherus, quoted by Val Williams, in *Elina Brotherus: Suites françaises 2* (Paris: &: gb agency, 2001), unpaginated.
2. As Brotherus has explained, many of the works in this series were shot with an extended exposure, and while a number of people may actually have passed through the shot, none remained still enough to leave a trace in the final images (Elina Brotherus, in "The Enchantment of Reality" [interview by Jan Kaila, 31 August 2001], in *Decisive Days: Elina Brotherus Photographs, 1997–2001* [Oulu, Finland: Kunstannus Pohjoinen, 2002], 135).
3. As Alex Farquharson has pointed out, Brotherus has her own definition of this term: "For her, photography's 'decisive moment' is not a split second alignment of people and light, but a passage of time lasting anything from a few minutes to a few weeks" (*The Citigroup Private Bank Photography Prize 2002, 1 February–31 March: Elina Brotherus*. The Photographers' Gallery. 30 May 2003 <http://www.photonet.org.uk/programme/citibank/citigroup02/brotherus.html>).
4. Elina Brotherus, "Sketchbook Notes," in *Elina Brotherus: Landscapes and Escapes: Suites Françaises 1* (Helsinki: Galerie Anhava; Reykjavik: i8 Galleri, 2000), unpaginated.

Elina Brotherus
Horizon 6, 2000
Chromogenic process color print
31 1/2 x 39 3/8 in. (80 x 100 cm)
Courtesy &: gb agency, Paris

39
Elina Brotherus
The Fundamental Loneliness, 1999
Cat. no. 10

40
Elina Brotherus
Femme à sa toilette, 2001
Cat. no. 14

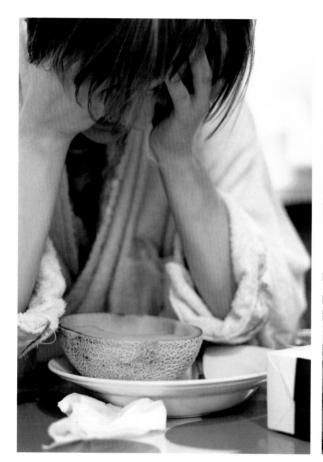

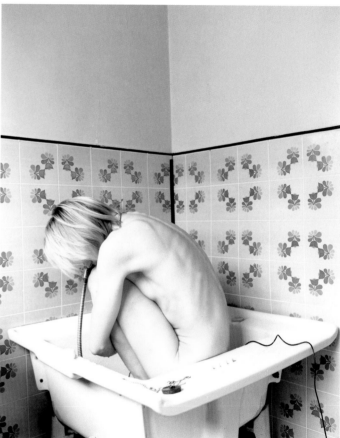

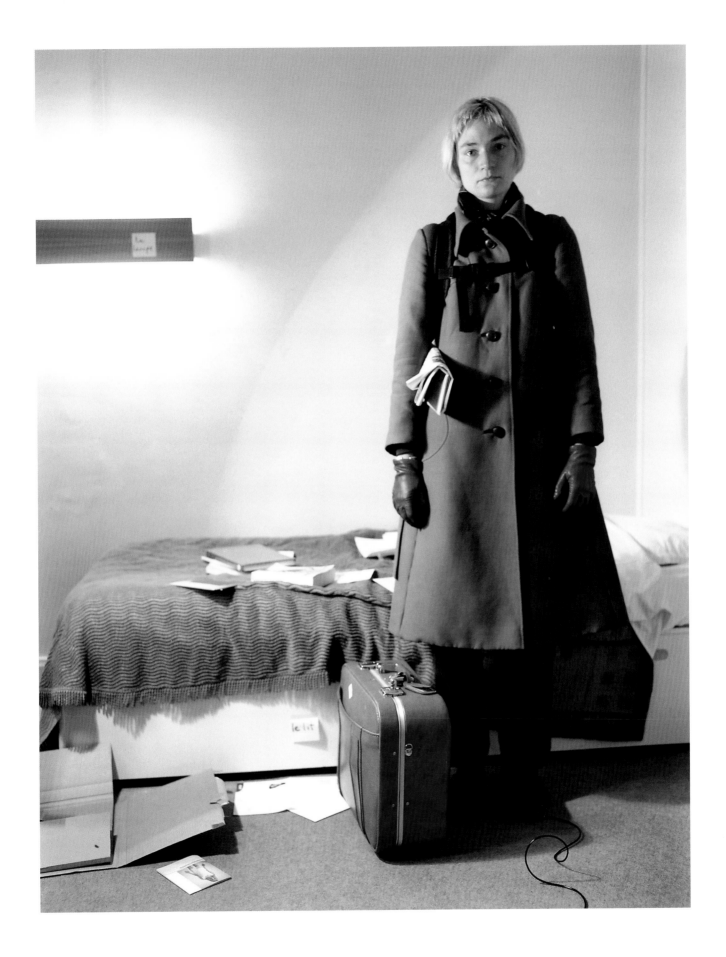

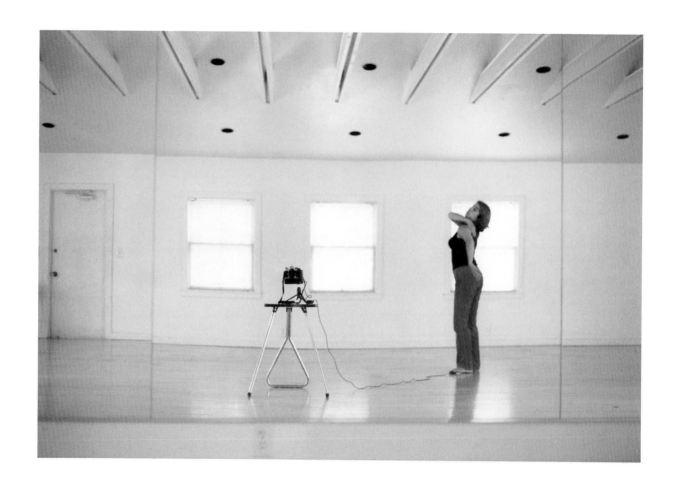

42
Dorit Cypis
Reversibility, 2001
Cat. no. 19

Working in photography, video, performance, installation, and social actions since the late 1970s, Dorit Cypis has pursued an ongoing investigation of the politics of representation and formal explorations of the complexities of looking, seeing, and being seen. From early performative video works and immersive slide-projection installations that confronted viewers with their complicity within the image, including projects in the late 1980s and early 1990s involving her naked body or direct gaze, to more recent large-scale photographs featuring visually disorienting and almost indecipherable spaces, Cypis has created works that engage viewers on visual, social, psychological, and phenomenological levels.

Mirrors, reflective surfaces, and images of the camera itself are some of the recurring elements in Cypis's most recent works exploring perception and the body in relation to social and interior space, as both physical and metaphysical. In the diptych entitled *Reversibility* (2001; fig. 42), she stands in a spare dance studio between a large mirror and a row of windows. With her camera next to her in the center of the room, she twists her head and torso as if attempting to see her back—a view of her body that she can obtain only with the help of a mirror's reflection. With the shutter release cable under her foot, Cypis shot *Reversibility*'s images with the camera's lens aimed toward the mirror. Not only does the mirror function here as a site of reflection on the artist's body, it serves as a disorienting device calling into question the viewer's position in relation to this image and collapses the space between the viewer and the subject.

Cypis returned to the highly reflective space of a dance studio in *Dancer's Dilemma 1* and *Dancer's Dilemma 2* (2002; fig. 43). In these images the camera's lens once again points toward and is reflected in the studio's mirrored wall. Seams between large sections of mirror have the effect of fracturing and disrupting the image of this space. While the artist's body was prominent in *Reversibility*, in these images it is all but absent.

In one image her crouched and barely detectable form appears peeking into the room from a reflected glass doorway, while in the second image the glass door is closed, and only a suggestion of her body is visible outside. Is the subject's body outside the physical photograph, outside the photographed space, outside the social space of the viewer, or deflected onto the viewer's body? A large poster against a side wall illustrating the musculature of the human body now appears in the dance studio—a subtle stand-in for the now "absent" physical body.

Cypis's photographic spaces become further complicated and disorienting in *Prisoner's Dilemma 1* and *Prisoner's Dilemma 2* (2002; figs. 44, 45), which were produced in conjunction with a project Cypis initiated with the Harbor Justice Center Superior Court House in Orange County. After teaching a class at the University of California, Irvine, that explored the visual codes of the courts (which involved studying the procedures of the justice system and interviewing many of the employees of the Justice Center), Cypis was granted access to the facility's temporary jail cells for a photo shoot. Of particular visual and conceptual importance to her was the fact that this jail was designed as a panopticon, a structure created to provide complete observation of every prisoner.[1] From within a small room of one-way mirrored glass built in the center of a larger room surrounded by and facing jail cells that hug its periphery, guards of this facility are able to watch the prisoners. Since one-way mirrored glass is reflective on one side, when prisoners look in the direction of their guards, all they see is themselves, never quite sure if they are being watched and by whom. It is within this disorienting architecture that Cypis positioned herself and her camera, creating two images that feature both her body and the camera's form trapped in a virtually unknowable space where reflective surfaces and reflected images create a sense of dislocation and displacement.

43
Dorit Cypis
Dancer's Dilemma 1, 2002
Cat. no. 20

44
Dorit Cypis
Prisoner's Dilemma 1, 2002
Cat. no. 23

45
Dorit Cypis
Prisoner's Dilemma 2, 2002
Cat. no. 24

74

The disorienting images of *Prisoner's Dilemma 1* and *Prisoner's Dilemma 2* evoke the French philosopher and social critic Michel Foucault's fascination with the panopticon and how such a structure of domination based on complete observation is the essence of power, having far more oppressive potential than physical control over a body.[2] Not only do Cypis's images suggest the power dilemma faced by prisoners, never sure if and when they are being watched, but it also creates a dilemma for viewers, since their position relative to the structure of the panopticon is also confused and destabilized. Questions of who and where is the "prisoner" lead to questions about where power lies. Cypis borrowed the title *Prisoner's Dilemma* from negotiation theory. It describes a hypothetical situation in which two criminals are accused of the same crime and jailed in separate cells. They cannot communicate with each other while each separately attempts to negotiate his or her freedom with the authorities. What neither prisoner knows is that one's negotiation depends on the other's. In Cypis's photographs this allegory becomes an instructive morality play on the relationship between the viewer and the viewed.

From an oppressive structure of confinement, Cypis moves to an exhilarating expression of release in two images titled *The Rest in Motion* (2002; p.5, fig. 12). In these images she captures views of a large curtain as it billows from an open window, set in motion by the force of turbulent winds. Shot from inside a hotel room in Tel Aviv, Israel, during a storm, these two images capture the curtain as it becomes wildly animated. As the curtain expands and collapses, attempting to break free of the visual and physical confines of the window frame and any fixed orientation of either inside or outside, it almost appears to breathe. Although the physical body is absent in these images, this curtain becomes a surrogate body, restless, determined, and euphoric.

The seductive restlessness of Cypis's curtains escalates to fury in another related work, *Mixed Motives* (2002; fig. 47), a large image of the Pacific Ocean during a dramatic storm. *Mixed Motives*, whose title is derived from a negotiation term implying the use of more than one strategy, is marked by a violent ocean with waves crashing on the beach that send foam and spray into the air. This agitated shoreline contrasts sharply with an opening of calm blue sky above—an unexpected respite in an otherwise tumultuous scene. A further and perhaps ultimate release comes in *Inside-Out* (2002; fig. 46), a series of utterly still images made in a peaceful, exotic interior space. Situated inside a thatch-roofed room structure in Tulum, Mexico, Cypis's camera now points toward the room's open windows, framing palm fronds angling down from the roof and overlooking a lush, green landscape. The bright sun outside contrasts with the vast, dark interior of this room, creating a meditative and reassuring space that becomes calming both visually and mentally. Once again, the body is absent in *Inside-Out* and yet, as with *The Rest in Motion* and *Mixed Motives*, images Cypis deliberately installs in relation to *Prisoner's Dilemma* and *Dancer's Dilemma*, they speak to the interior world of the body/mind. With traces of each image adding meaning to the others, these works embody various psychic states, often impacting the viewer on a visceral level.

NOTES

1. English philosopher and theorist of British legal reform Jeremy Bentham (1748–1832) proposed the architectural innovation of the panopticon as a design for safer prisons. The "all-seeing" panopticon called for a prison space constructed as a circular arrangement of inward-facing jail cells, at the center of which is an observation station with special shutters or windows to prevent the prisoners from seeing the guards. The central goal of the panopticon was control through both isolation and the possibility of constant surveillance.

2. See Michel Foucault, "Panopticism," in *Discipline and Punish: The Birth of the Prison* (New York: Vintage Books, 1995), 195–228.

46
Dorit Cypis
Inside-Out, 2002
Cat. no. 21

Dorit Cypis
Mixed Motives, 2002
Cat. no. 22

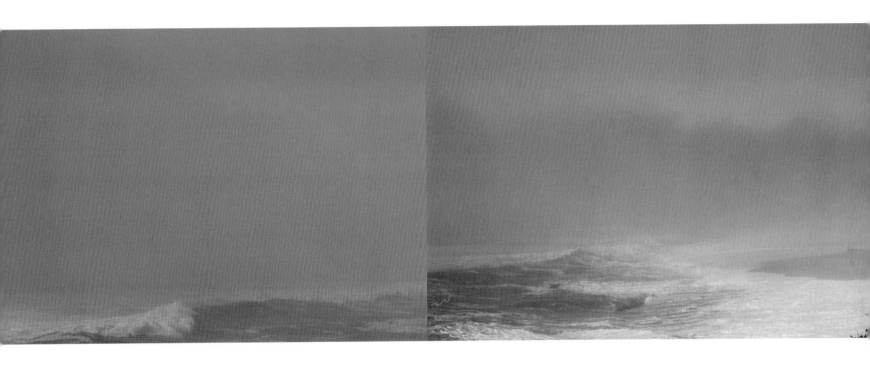

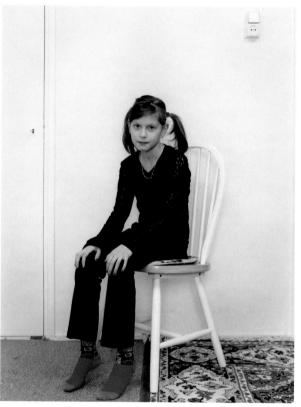 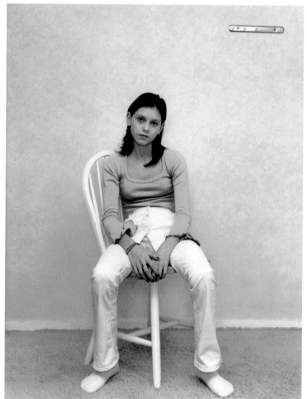

48, 49
Rineke Dijkstra
Almerisa, Wormer, Netherlands, February 21, 1998, 1998
Almerisa, Leidschendam, Netherlands, December 9, 2000, 2000
Cat. nos. 30, 31

Rineke Dijkstra's stark and brutally honest large-scale portraits and video works are marked by their capacity to express the beauty in flawed or vulnerable subjects. Through her highly formal and psychologically charged images, Dijkstra invests the traditional genre of portraiture with a fresh perspective. Her penetrating and iconic portraits reveal poignant qualities of innocence and fragility, recalling the documentary tradition of photographers such as August Sander (1876–1964) and Diane Arbus (1923–1971).

When Dijkstra began taking her portraits in 1992, she initially invited her friends to be her subjects, but once she realized that they were too concerned with posing and manipulating their own image, she turned to a more anonymous and ultimately more open subject—the teenage girl. Dijkstra explains: "I photographed a teen girl I didn't know, but whom I had approached. This portrait turned out to have such a beautiful lack of inhibition that I decided to continue."[1] Early on, Dijkstra began to work in series, each time focusing on a particular group or community. "In my work," she writes, "I look for specific characteristics of individual people within group settings."[2] From portraits of first-time mothers just days or even hours after giving birth, to images of young Portuguese matadors as they step out of the bull ring, to young men and women training for the Israeli army, Dijkstra's subjects are inherently vulnerable and are often caught in a transitional moment in their lives.

The images that first brought Dijkstra to the attention of the art world were a series of large-scale portraits of teenagers posing in their bathing suits on a beach. Her Bathers series from 1992–96 features images that show her subjects isolated against the backdrop of the shoreline. Self-conscious and exposed, her bather subjects epitomize the awkwardness of the teenage years. Her use of a large-format camera, which required her subjects to hold a pose for a long time, added to their anxiety and hyperawareness about being photographed

in their bathing suits, while at the same time allowing them to become more at ease with her deliberate process. Dijkstra's subtle use of flash reveals precise details, contributing to a look of artificiality and a sense of uniformity in these images that strips away most clues about time of day or location. The only indication that we might be looking at a teenager from Coney Island, as opposed to one from Croatia or Poland, might be the slightly more updated style of the bathing suit or the subject's somewhat more sophisticated, and perhaps media-inspired, pose. These images present various levels of psychological and physical vulnerability, and collectively they form a quasi-anthropological study of adolescence.

An invitation to photograph children of refugees in Holland led to one of Dijkstra's subsequent series, in which she had the opportunity to document the effects of time and change on an individual. This series, begun in 1994, developed after Dijkstra met a young Bosnian girl named Almerisa, who at the time was living with her family in a Dutch refugee facility. In her first image of Almerisa, the timid young girl, only six years old, sits on a red chair in her Bosnian Sunday clothes, with her tiny legs dangling over the seat (fig. 17). The spare interior setting lends a cold and somewhat institutional feeling to this initial portrait. Learning that Almerisa and her family had stayed in Holland after she shot this image, Dijkstra then reconnected with her every two years to shoot another portrait, each time posing her in a chair somewhere in her home. With each image Almerisa becomes more confident and striking. In the third photograph (fig. 48), even before her legs firmly touch the ground, we see her defining her image through her hairstyle, jewelry, and painted lips and nails, and we encounter a defiant gaze that only intensifies two years later as she enters adolescence (fig. 49). Comprising six images, Dijkstra's Almerisa series not only reveals the dramatic physical changes of the passage from girlhood to womanhood but also exposes the intense psychological transformation as well.

50
Rineke Dijkstra
Kolobrzeg, Poland, July 26, 1992, 1992
Cat. no. 27

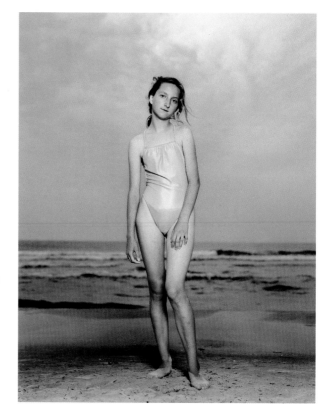

In her mesmerizing video *The Buzzclub, Liverpool, England /
Mysteryworld, Zaandam, Netherlands* (1996–97; figs. 27, 52, 53),
Dijkstra introduced the elements of time, sound, and
movement to her portraits of teenage subjects. Side-by-side
projections present footage she shot in two teenage dance
clubs, one in Liverpool, England, the other in Zaandam, the
Netherlands. In a small, brightly lit room behind the dance
floors of these clubs, Dijkstra set up a studio and invited
young clubbers to dance alone in front of her camera to the
deafening techno music. Isolated from their friends against a
stark white background, the teenagers smoke, drink, and sway
to the beat. Some are highly self-conscious as they awkwardly
face the camera in their tight-fitting clothes and heavy
makeup, which only appear more artificial in Dijkstra's austere
setting. Other dancers come off as more confident and at ease
in front of the camera as they respond to the music, many of
them becoming increasingly more uninhibited as the video
(and the night) goes on. Part documentary, part
anthropological study, *Buzzclub / Mysteryworld* offers an
entrancing glimpse into the lives of teenagers that is at once
hilarious and touching as it captures the range of emotions
associated with this turbulent time of life.

Most recently, Dijkstra has begun a new series that engages
a group of young ballet dancers from Santa Ana, California.
These girls, who come from lower-income families in Orange
County, all belong to Saint Joseph Ballet, an intensive after-
school dance program that provides ballet instruction to at-
risk youth. Dijkstra's portraits of these young girls, all between
the ages of twelve and sixteen, not only reveal the gracefulness
that is developing in their bodies and postures but also focus
on their striking and intense faces, which suggest life
experiences and hardships beyond their years. These highly
sympathetic portraits, like those in all of Dijkstra's series, have
heroic qualities, capturing the dignity of often insecure and
exposed subjects.

NOTES
1. Rineke Dijkstra, in Claire Bishop, "Rineke Dijkstra: The Naked
 Immediacy of Photography," *Flash Art* 31 (November–December
 1998): 88.
2. Rineke Dijkstra, in *Israel Portraits* (Herzliya, Israel: Herzliya
 Museum of Art, 2001), 5.

Rineke Dijkstra
Still from *The Buzzclub, Liverpool, England / Mysteryworld,*
Zaandam, Netherlands, 1996–97
Cat. no. 34

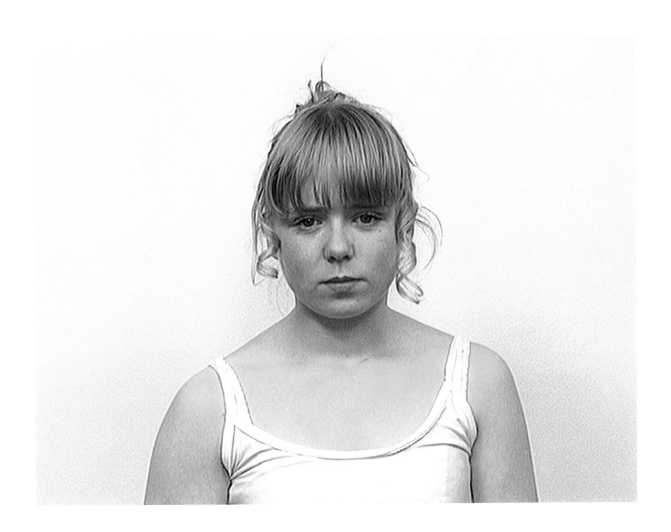

54
Katy Grannan
Van, Red Hook, NY, 2003
Cat. no. 46

Katy Grannan creates portraits that engage a variety of related fields, including fine art, journalism, and fashion. They are informed by a photographic tradition that stresses objectivity, pioneered by figures such as August Sander (1876–1964) and carried on by Diane Arbus (1923–1971) and others. Although Grannan's approach to her sitters has an ethnographic character, reflecting an interest in registering cultural information, her work has been described as "pseudo-documentary." Poetic and stoic, her portraits are rich in references to fashion magazines, pinups, snapshots, and, in her most recent images, the work of classical painters associated with the genre, such as Jean-Auguste-Dominique Ingres (1780–1867) and Edouard Manet (1832–1883).

Seminal series such as Poughkeepsie Journal (1999) and Dream America (2000) established Grannan's modus operandi. The artist placed an ad in the classified section of small-town newspapers, under the heading "Art Models," identifying herself as "Artist / photographer (female)" and simply stating that she sought "people for portraits." Both female and male subjects answered, and after initial telephone contact, she arrived at her pool of sitters. The models selected were young men and women of blue-collar socioeconomic backgrounds. They posed alone, with their children, as a family, or as a couple, with many sitters choosing to pose in the nude. Grannan brought only her camera, two lights on a stand, and an electric fan to the photo sessions, which never lasted longer than three hours.

Turning her subject's living rooms or bedrooms into a studio, Grannan moved pictures and furniture, sometimes adding things found elsewhere in the house. In collaborating with each of her sitters on decisions regarding the staging of the room, what (if anything) they would wear, and how they might pose, Grannan established a rapport with her models that reveals itself in the final portraits through a directness that exposes the sitters' perceptions of themselves. Despite the amateur nature of the models, these images do not seem particularly voyeuristic; rather, they possess a poignant sense of empathy and sensitivity to the desires of the sitter.

Although both men and women responded to Grannan's ads, her subjects are for the most part young women. In many cases they were photographed in the childhood homes where they still live with their parents, and they often scheduled time to meet with Grannan when their parents were not home. These were not glamorous photo shoots, and the images that resulted, with their stark lighting, are not particularly flattering, yet Grannan's subjects appear surprisingly uninhibited and open to the process. Perhaps they ultimately took pleasure in playing out their fantasies of being models or in the feeling that their collaboration with the photographer was slightly forbidden or surreptitious.

In a recent series titled Morning Call (2001–3), Grannan solicited sitters in New York and Pennsylvania through her usual newspaper ads. In this series, as in previous ones, there is a striking similarity in the decor of the homes, identifying them as simple, middle-class suburban homes—exactly the kinds of interiors that remind Grannan of her own childhood. Not only are wood-paneled walls common in these interiors, but so is the appearance of artificial nature. Ivy- or bamboo-print wallpaper, fake flowers, and floral upholstery and drapery become active and dominant elements in portraits such as *Van, Red Hook, NY* (2003; fig. 54) and *Dee, Red Hook, NY* (2003; fig. 57). For this particular series, Grannan chose to shoot in black-and-white film for the first time, an aesthetic decision that has the effect of highlighting the strong graphic quality of the many patterns in these spaces while at the same time referencing the historical tradition of portrait photography.

55
Katy Grannan
Barry, Bethlehem, PA, 2002
Cat. no. 39

Concurrent with her Morning Call series, Grannan was also working on a new body of work entitled Sugar Camp Road. Named after a park in Pennsylvania, this series marked a new direction for Grannan in that she now moved her photo shoots to the outdoors, meeting and photographing her chosen sitters in public parks. In these works, rich with color and painterly references, the landscape becomes a backdrop for works that conflate private and public space. Although the settings of these works are lush and beautiful, one cannot help but be reminded that such secluded locations have often served as the context for violent crime. The title of the series alludes to this, as Sugar Camp Road was the site of a particularly heinous and publicized murder of a young girl. As Grannan points out, such incidents were often on her mind and on the minds of her sitters, since "the idea of an idealized landscape is so often complicated by a sordid history."[1]

In a work such as *Carla, Arnold Arboretum, Jamaica Plain, MA* (2002; fig. 56), we see how Grannan's portraits translate to the outdoors. As in some of her domestic portraits, her nude sitter's clothes are deliberately included in the shot, but this image additionally conveys a sense of haste and a heightened awareness of the model's nakedness. Carla's tentative posture and her rumpled pile of clothing make us acutely aware of the exposed, public, and perhaps even dangerous nature of the space, with the photographer and model having seemingly ducked under a tree for just a moment to shoot this image. This is no longer Manet's *Déjeuner sur l'herbe*, but a powerful update on the theme that reveals the fundamental shift in the gaze that is inherent in Grannan's works and is informed by contemporary fears of the secluded landscape.

NOTES

1. Katy Grannan, correspondence with the author,
 1 June 2003.

57
Katy Grannan
Dee, Red Hook, NY, 2003
Cat. no. 43

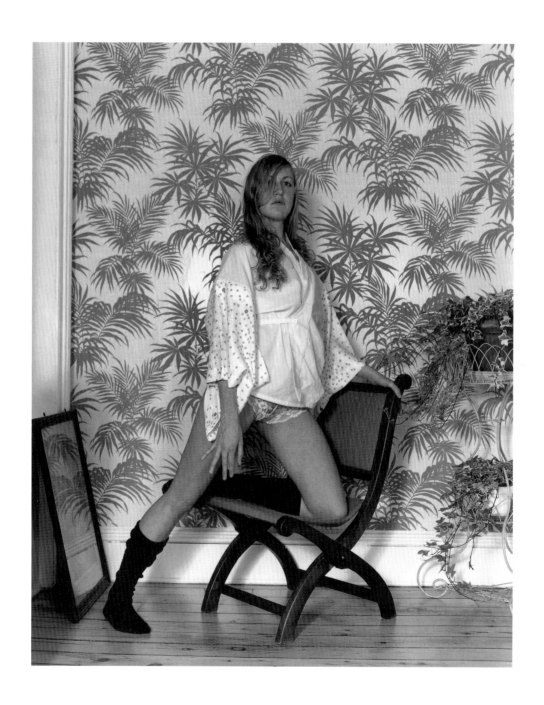

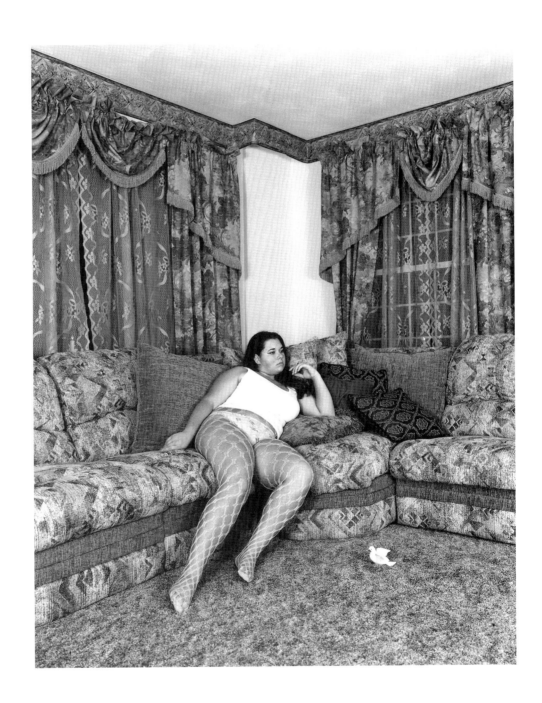

59
Sarah Jones
Consulting Room Couch (XIV), 1997
Cat. no. 47

Whether photographing moody teenagers, solitary urban gardens and parks, or empty therapist's offices, Sarah Jones creates complex and seductive images that are marked by alienation and absence. At times evoking the paintings of Jan Vermeer (1632–1675), Diego Velázquez (1599–1660), or Balthus (b. 1908), Jones's meticulously controlled and rigorously framed large-scale photographs oscillate deftly between reality and artifice.

In one of her earliest bodies of work, the Consulting Room Couch series, begun in 1995 (see fig. 59), Jones photographed the beds and couches in a London institute of psychoanalysis. While these images at first appear conspicuously vacant, spare, and similar, they are in fact rich with distinguishing details and palpable traces of anonymous bodies. The impressions on the pillows and mattresses evoke absent clients, while the position of blankets and pillow protectors reveals subtle changes to couches that Jones photographed over time. Printed life-size and hung at a height that references a bed, these images relate strongly to the body while at the same time confronting the viewer's psychic baggage.

For the past six years, Jones's work has centered on another psychologically complex subject: teenage girls. In the Dining Room series, begun in 1997, she created portraits of three fourteen-year-old girls posed in the formal dining rooms of their homes in the English Midlands. In each of these images Jones created a highly charged atmosphere as her subjects adopted uneasy and at times defiant postures. Their expressions and body language express boredom, restlessness, self-consciousness, and indifference in a way that only an adolescent can. When more than one of the girls appear together, as in *The Dining Room (Francis Place) (I)* (1997), the tension increases as they start to ignore or position themselves in relation to one another. Sulking and narcissistic, these girls express a conspicuous disregard for their surroundings.

Jones's strongly lit and highly colored images bring out the contrasts between the casual clothes and postures of the girls and the details of the immaculate bourgeois interiors. These are formal rooms; if the houses are not quite aristocratic mansions, they are nonetheless places of power, wealth, stability, and social status. Highly polished furniture, richly colored walls, and ornate Asian ceramics provide an uneasy backdrop for a posing teenager. Jones's carefully staged scenes and the considered cropping of her images create a psychological tension in these works, leading us beyond the visible limits of the photograph to wonder what it is that we do not see. These are strong compositions that only accentuate the tensions set up by the girls and the rigid symmetry of the decor of their homes.

Jones has revisited these girls over the course of several years, and her camera has been witness to the physical and emotional changes—both dramatic and subtle—in her adolescent subjects. In *The Wall (Francis Place) (I)* (1999; fig. 63), an image from a series that moves the girls out of their homes and into their family gardens, one of the girls lies on a low garden wall. Her left arm hangs down from the wall, and her hair covers her face, looking just as wild as the brush growing below, along the wall. She is decidedly more dramatic and disheveled than in previous images; perhaps she has become more at ease with her own developing body and with posing before the camera. All of the girls in fact appear less inhibited in these outdoor settings than they do in the confines of their parents' homes. Noticeably overpruned trees, flowering bushes, and mysteriously dark backgrounds all seem more congruous with the temperament of Jones's adolescent girls.

In addition to works that show girls posing in a garden setting, these series also include a number of evocative works that feature the same gardens, with the girls now

60
Sarah Jones
The Sitting Room (Francis Place) (V), 1997
Cat. no. 49

61
Sarah Jones
The Spare Room (Francis Place) (V), 1998
Cat. no. 50

conspicuously absent. In *The Pear Tree* (1998), for example, a
pruned pear tree becomes an uncanny surrogate for the figure.
More dramatic yet are some of Jones's most recent works, such
as *Ilex (Holly) I* (2002; fig. 62), part of a group of images shot
at dusk in a London park. Here a dramatically lit and framed
solitary tree becomes highly charged as its sinuous form
evokes the menacing associations of the forest, while at the
same time serving as a haunting stand-in for the bodies and
emotions of Jones's affected young subjects.

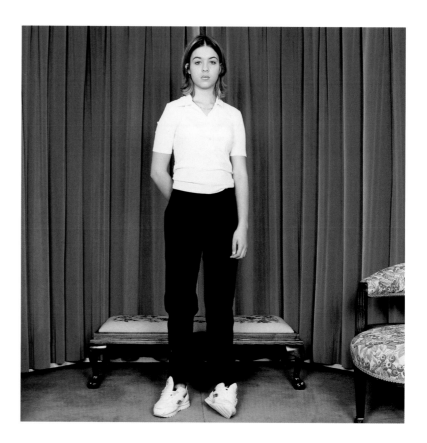

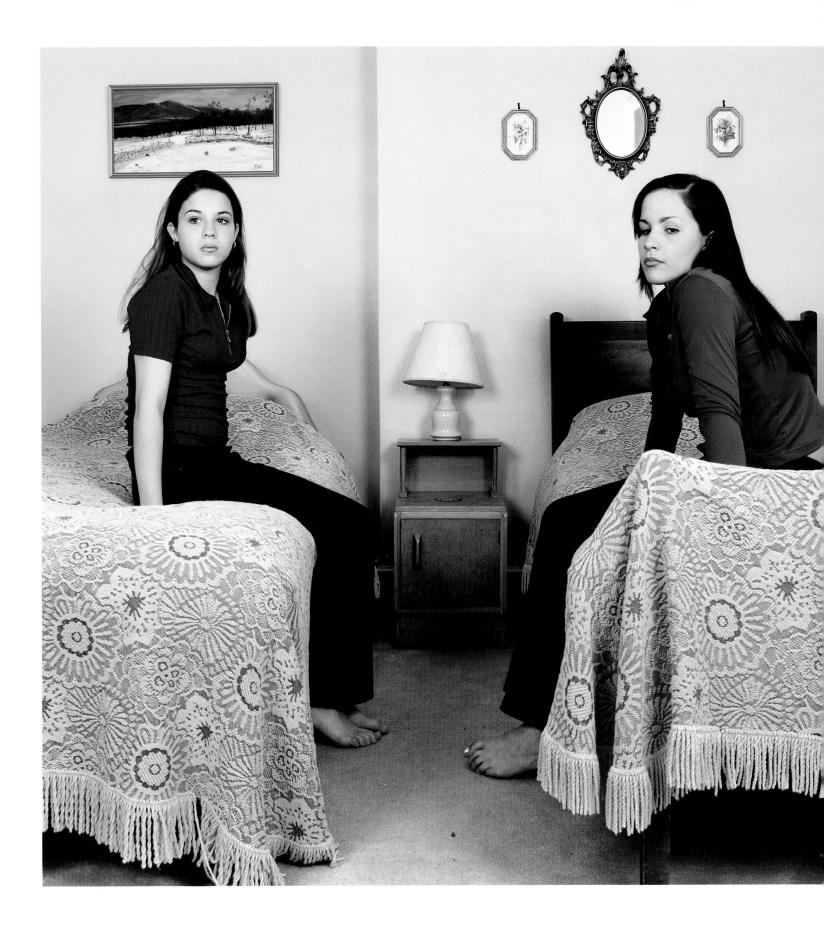

62
Sarah Jones
Ilex (Holly) I, 2002
C-print on aluminum
60 x 60 in. (150 x 150 cm)
Courtesy Maureen Paley Interim Art, London

Sarah Jones
The Wall (Francis Place) (I), 1999
Cat. no. 51

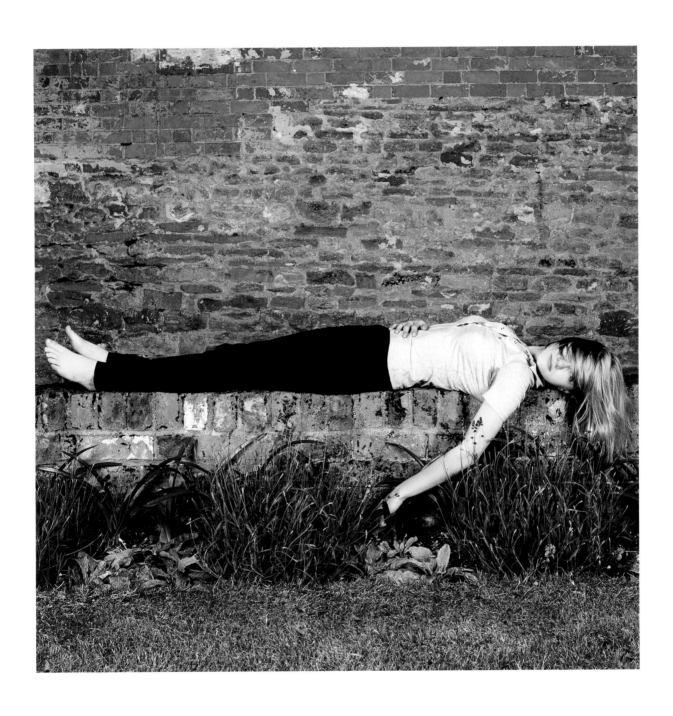

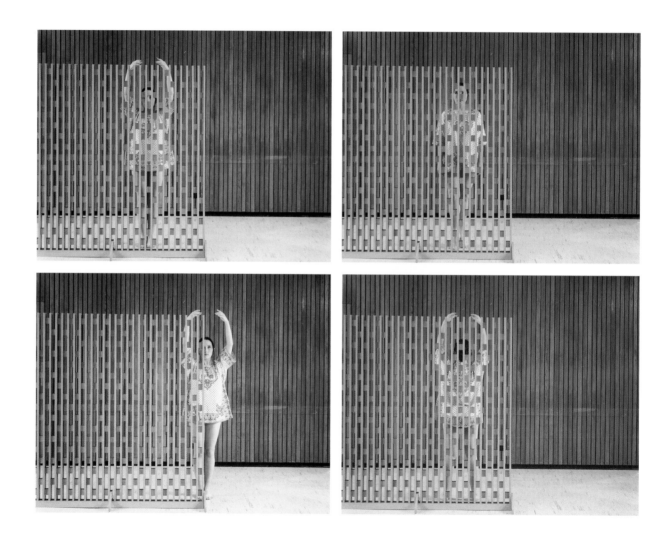

64
Kelly Nipper
interval, 2000
Cat. no. 53

Kelly Nipper creates austere and carefully executed works based in photography, video, and performance, which explore nuances related to time, motion, weight, space, and dimension. Often employing dancers and meticulously choreographed activities and movements, Nipper's works are poetic studies of motion and relationships. Although her highly formal works often engage precise structures and systems, they nonetheless leave room for the introduction of chance and the possibility of a collapse of order, revealing such influences as Yoko Ono's open-ended poetry and instruction performances and Allan Kaprow's happenings, environments, and activities.

Drawing on such models, as well as on Merce Cunningham's concepts of fluid and improvisational dance movement and Hélio Oiticica's theories on free-form space and color, Nipper's newest and most ambitious work to date is a four-channel video projection installation that explores balance, motion, and the interior space of the body, employing images and metaphors connected to water, ice, and figure skating.

The central video in *Bending Water into a Heart Shape* (2003; fig. 66) features a single female dancer moving in slow motion through the movements of a counterrotation figure-skating jump known as a lutz.[1] Standing on the floor of a studio, the dancer, Phithsamay Linthahane, moves through the positions of a triple lutz, attempting to stretch the movement out to an excruciating sixty minutes. In an intensely meditative state, she continues to shift and counterbalance her weight, slowly spinning up on her toes while the camera remains stationary.

Linthahane's face and body reveal the extreme physical and mental intensity of her movement, recalling the unconventional and at times unconscious movements of the avant-garde dance form Butoh.[2] Internal martial arts training prepared the already agile and disciplined dancer for a change in her body and mind, allowing her to attempt to move both into empty space and in a state of total openness that would produce the appearance of fluid and effortless movement.[3] Although Linthahane's training prepared her mentally and physically to perform the movement, the final execution was anything but effortless. As Nipper's video reveals, at times her muscles failed her as she attempted to hold a position, while at other times she fell momentarily out of balance. Related to the footage of this video are several passages of rap lyrics written by Nipper. While these lyrics echo or reference some of the shapes and motions employed in *Bending Water into a Heart Shape*, they also suggest how these elements might reappear and expand in other contexts.[4]

Connecting Linthahane's movement to the site most associated with a lutz are two videos made at a figure-skating training center, each shot from opposite sides of a spinning turntable positioned in the middle of the ice. This footage presents two dizzying views of the perimeter of the rink, visually suggesting the field of vision of a pair of spinning skaters. The fourth video of this installation features a delicate spiral mobile composed of wire and teardrop shapes made of ice. The video records the process of the ice melting, which slowly and unpredictably throws the mobile out of balance as its weight and shape gradually change. Within this quiet and poetic video, the concepts of *Bending Water into a Heart Shape* converge. The slow and physical transformation of water from one state (solid) to another (liquid) references Linthahane's mental and physical transformation, while the spiral construction of the mobile echoes her slow, rotating movement and the two spinning views from the training rink's center. Like the dance footage, this work is dominated by the intervention of chance and the loss of control. During Linthahane's lutz movement, her body becomes unpredictable and inconsistent under the mental and physical stress, while in this video the mobile's melting forms cause the wire and ice structure to fall out of balance as it literally disappears.

Together, the four large-scale video projections that make up *Bending Water into a Heart Shape* explore such concepts as control, balance, and change. As Nipper's enigmatic title suggests, the work is also a study of circular shapes: the spiral of the mobile, the spinning movement by Linthahane, and the two related rotating rink views that suggest the form of conjoined circles, a heart shape. Marked by elegant forms, movements, and images combined with subtle ruptures in order, *Bending Water into a Heart Shape* is a poetic and complexly layered work that embodies many of the concepts and influences that have shaped Nipper's artistic practice.

The conceptual and aesthetic roots of *Bending Water into a Heart Shape* can be found in a number of Nipper's earlier works that have involved choreography, movement, and the visualization of intense mental states. In the photographic sequence entitled *interval* (2000; fig. 64), for example, Nipper explored time and motion through an elegant series of images featuring four seemingly related positions held by a dancer. In this simple yet enigmatic sequence, she calls attention to unknown movements between the frames while introducing a subtle disruption of logical order. Just as *interval* suggests the hidden activity that takes place in the space between a series of motions, Nipper's new work records the intense mental (and similarly hidden) activity of Linthahane's transition into empty space.

Norma—practice for sucking face (1999; fig. 65)—an installation lasting ten days, which featured a group of dancers and a highly structured score of pedestrian movements—was, like *Bending Water into a Heart Shape*, an exercise in controlled movement, but it too was made richer by the introduction of chance and the unknown. The elements of this work included a group of dancers, a large platform, 120 gray cushions, five sets of sculptural objects, and a numeric score counted in French by Linthahane, who was one of the dancers.5 An element of chance was introduced into the work in the form of the gallery audience, whose presence in the space at times affected the actions and prescribed configurations of the dancers, who spent each day reconfiguring the gray cushions

in relation to the large platform in the gallery. The dancers' own physical and mental fatigue also impacted the piece, as they gradually fell out of precise time, constantly changing the atmosphere and physical configuration of the space.

In many of Nipper's works the concept of time is an essential element to be exploited and explored physically, mentally, and visually. It is perhaps in her recent work, *Bending Water into a Heart Shape*, that time has the greatest impact on her audience. There is a sense after seeing Linthahane move slowly through part of the lutz motion, or after watching the ice forms on the mobile melt drop by tiny drop, that part of an understanding of this work is in the endurance of experiencing its images. These quiet and poetic forms reveal themselves slowly, asking viewers to readjust their usual hurried pace and to give themselves over to an experience that explores some of the elemental relationships and abstract correspondences between the body and mind.

NOTES

1. The distinguishing feature of this difficult skating maneuver is that the skater enters the jump moving in one direction and concludes the jump skating in the opposite direction.
2. Butoh, which connects conscious and unconscious movements, is characterized by striking, unconventional movements and a transformation in the body.
3. Linthahane trained with internal martial arts instructor Joseph Zeisky, with an emphasis on Ba Gua, a practice that fosters a deep state of meditation, allowing one to become centered and calm while conditioning the body, expanding flexibility, and improving fighting abilities. The so-called internal martial arts are characterized by the use of the force of the entire body, rather than isolated muscle groups, and by the influence of Taoist spiritual practice.
4. These rap lyrics, entitled "In the Floating World," foreshadow Nipper's still-unrealized project of the same title. Not only do these lyrics thus connect *Bending Water into a Heart Shape* to this future work, but their title also reveals Nipper's interest in the images and philosophy embodied in ukiyo-e during the Edo period (1615–1868) in Japan.
5. In addition to Linthahane, the other dancers in this work were Anna Nuse, Allison Westfall, Dani Lunn, and Laura Koyle. The movement coordinator was Liz Maxwell, and the French adviser was Sheila Espinelli.

Kelly Nipper
Installation view of *norma—practice for sucking face*, 1999
Framed chromogenic process color print
11 3/8 x 17 3/8 in. (28.9 x 44.1 cm)
Courtesy galleria francesca kaufmann, Milan

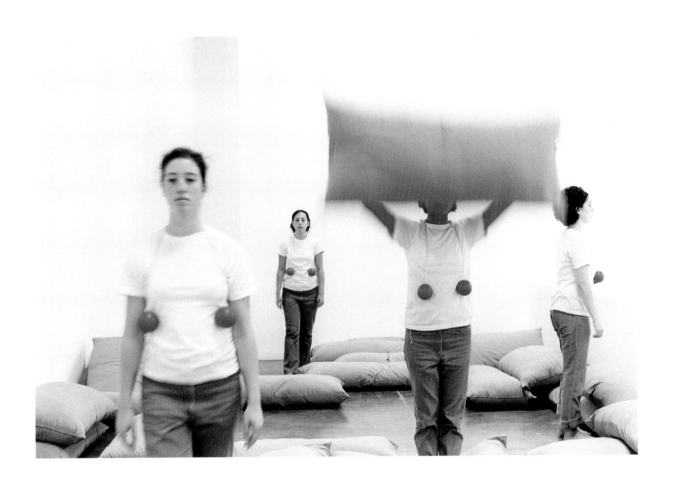

66
Kelly Nipper
Stills from *Bending Water into a Heart Shape*, 2003
Cat. no. 54

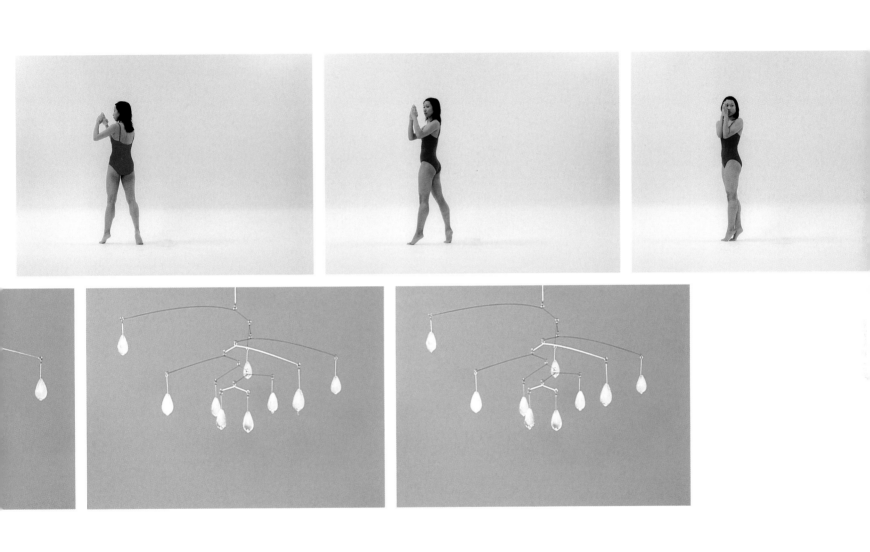

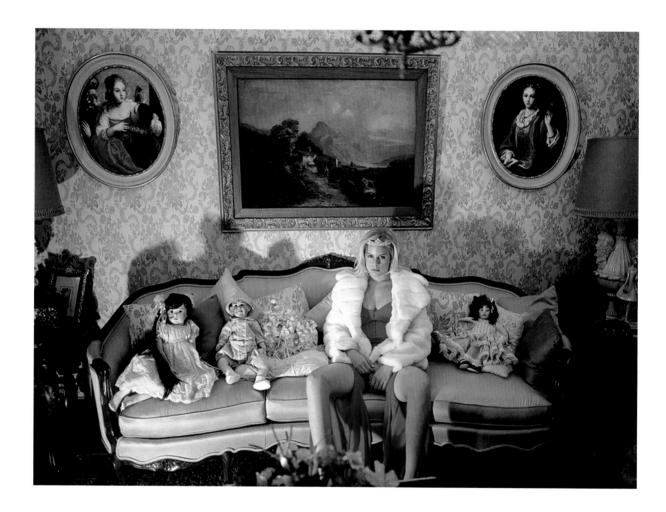

67
Daniela Rossell
Untitled (Ricas y famosas), 1999
Cat. no. 58

Daniela Rossell creates sumptuous and outrageous images of privileged young women that are equal parts ethnographic document and society portrait. *Ricas y famosas* is Rossell's ongoing series of photographic portraits of members of Mexico City's nouveau riche class posed in the private spaces of their opulent homes. With a level of access to and intimacy with her subjects only possible because of her own friendships and even familial relationships with them, she offers us a glimpse into the excessive lives and material possessions of some of her country's wealthiest and most powerful families. Drawing on influences ranging from the portraits of Spanish court painter Diego Velázquez (1599–1660) to contemporary Mexican soap operas, Rossell creates provocative images that are as glamorous as they are critical, at once addressing class, wealth, and identity.

Although Rossell's portraits are part of a lineage of Mexican photography linked to Manuel Álvarez Bravo (1902–2002), her models are far removed from Bravo's common subjects. As Barry Schwabsky has pointed out, "She focuses her ethnographic gaze not on the daily lives of the humble and the immemorial customs and traditions, but rather on her own class, the oligarchs whose economic and political power keeps the humble in their place."[1] Many of Rossell's subjects are in fact related to political figures who have played important roles in recent Mexican history. Paulina Dias Ordaz—the daughter of a former president of Mexico and the stepniece of Carlos Salinas, a disgraced and exiled leader accused of embezzling money from the government—is one of Rossell's glamorous young blonde subjects. In one of her portraits she is sexy and confident as she poses in an ostentatious parlor room dressed in a racy tennis outfit (fig. 69). Leaning against an opulent piece of furniture, she puts one foot up on the head of a stuffed lion on the floor of the room, throwing a flirtatious look at the camera.

Inge, a friend of Rossell's stepsister, is another prominent subject in this series. In one image she languishes in her living room on a large gold couch, staring up at the camera (fig. 68). Gold lamé throw pillows on the couch match the tight minidress she wears. Shot from a staircase high above the room, Rossell's image captures the details of this room's elaborate chandelier, large-scale paintings, and oversize Louis XVI–style furniture. In the corner behind the couch stands a maid, compliantly looking up at the camera as if waiting to be dismissed.

In another image Inge sits on a pink couch surrounded by lace pillows and rosy-cheeked dolls in frilly clothes (fig. 67). In a red party dress, a white faux fur jacket, and a rhinestone tiara, she stares almost vacantly at the camera. Although her outfit and accessories are glamorous and adult, they are at odds with her slouching posture, pouting expression, and spread legs—a striking collision between developing maturity and teenage defiance.

The same kind of tension between childhood and adulthood is present in a number of other images that feature Rossell's subjects posing in childhood bedrooms that they have clearly outgrown (see fig. 84). Surrounded by dolls, stuffed animals, family photos, trophies, and other vestiges of their girlhood, her subjects wear skimpy outfits and adopt sexy poses as they vamp unabashedly for the camera.

In a book published in 2002 that brought together the *Ricas y famosas* series, the images are preceded by the words: "The following images depict actual settings. The photographic subjects are representing themselves."[2] This introductory statement, while curious, serves to clarify the position of the artist, since the excesses of these images are at times hard to accept as "real." Despite their over-the-top theatricality, however, and the sense that they are highly controlled and

staged by the subjects themselves, Rossell's lavish images are ultimately sincere and brutally honest portraits.

Not only did the publication of this book bring Rossell's work to the attention of the international art world, it also made these images available to people in her own country, causing an unexpected stir among the press and hostility directed toward the artist, particularly by many of her sitters. Although her subjects were initially pleased with their images (having presented themselves as they wished to be seen), they became indignant once the press began to weigh in on these unflinching depictions of their wealth, taste, and excess. In retrospect they seemed to be embarrassed that their lifestyles had been exposed, having perhaps naively miscalculated how they would be perceived by the public, not realizing how much their images would serve as glaring reminders of the economic inequities and class tensions that continue to plague Mexico. While Rossell's images ultimately present a parody of the artist's own background and upbringing and a critical look at an extravagant lifestyle, they also reveal her empathy for a group of women sheltered and even trapped by their own privileged circumstances.

NOTES
1. Barry Schwabsky, in *Daniela Rossell: Ricas y famosas* (Madrid: Turner Publications, 2002), unpaginated.
2. Ibid.

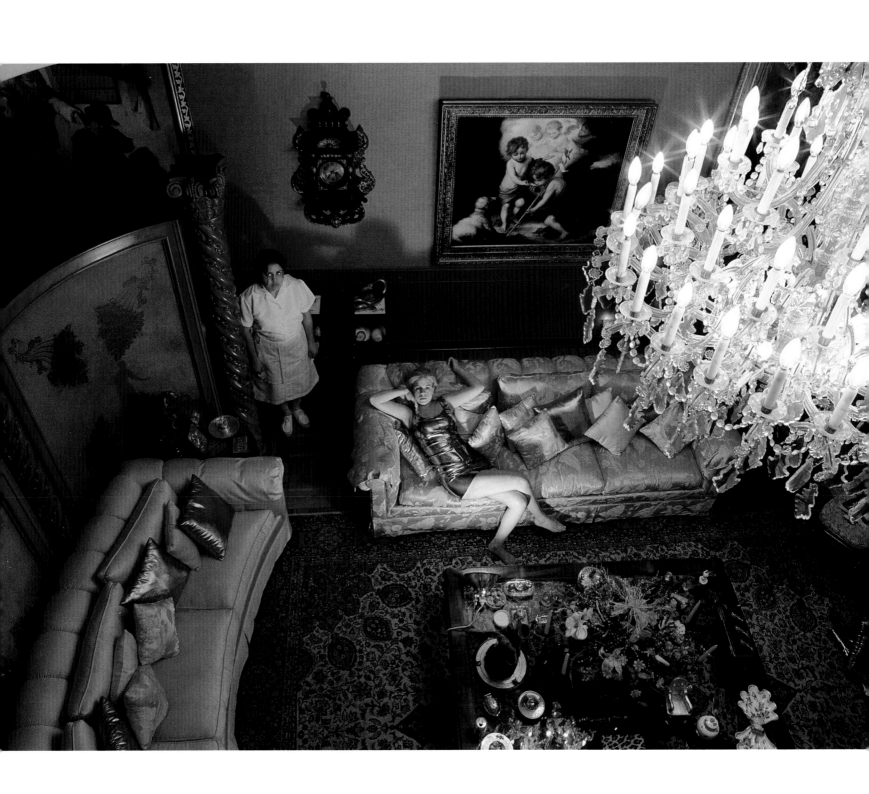

 106

71
Shirana Shahbazi
From *Goftare Nik / Good Words*, 2000–2003
Cat. no. 62

Born in Tehran, educated in Germany and Switzerland, and currently living in Zurich, Shirana Shahbazi makes photographs that explore the complexities of contemporary Iranian culture through a series of cityscapes, landscapes, portraits, and images of everyday life. Neither didactic nor ironic, her image making draws from a variety of formal sources, from the cool objectivity of contemporary German photography (including the work of Thomas Ruff and Thomas Struth) to the commercial aesthetic of political propaganda and billboard paintings. Unlike work that critiques Islamic fundamentalism and its social and political stance toward women, Shahbazi's images suggest that life in her native Iran, while at times contradictory, is more fluid and open than the narrow view perpetuated by cultural stereotypes would allow.

In *Goftare Nik/Good Words* (figs. 71–76), an ongoing project that she began in 2000, Shahbazi suggests the paradox of postmodern Iranian life: a harmonious yet conflicted world caught between long-established traditions and forays into uncharted territory. In titling this series of images after the ancient Persian dictum "Good thoughts, good words, good deeds," Shahbazi reveals her own optimism about the reality of life in her native country. The images she creates of urban scenes, landscapes, social celebrations, and daily situations coexist to form an exuberant mosaic, particularly since the ever-changing installations of *Goftare Nik* feature dozens of images of various sizes that cover gallery walls from floor to ceiling, depending on the site. In addition to her documentary-style photographs, which are a combination of staged scenes (mostly of Shahbazi's family and friends) with occasional spontaneous images, *Goftare Nik* also incorporates paintings Shahbazi has commissioned from Iranian sign painters. Beginning with a photograph she has taken, she hires a sign or billboard painter to create a new image based on the photograph. The style of these new works, which

become part of her installations either as paintings or as photographs of the commissioned paintings, reflect the identity of their makers as commercial artists who work primarily with political propaganda images or cinema advertising. Exhibiting these commissioned works along with her photographs, Shahbazi establishes a rich dialogue suggesting the contradictory nature of contemporary art practices, as well as broader issues related to Iranian life.

Keenly aware of the legacy of Orientalism in the West, reflected in a tendency to present an exoticized view of Eastern cultures, Shahbazi sidesteps images, references, and attributes that might reinforce essentialist constructions of Iranian or Islamic identity. In *Goftare Nik*—instead of the clichéd odalisque, desert scene, or architectural ornament— one finds a reality that has been edited to its barest expression. Simple, everyday situations are depicted: a child wearing roller blades, a young woman working in a pharmacy, an urban scene of modern Teheran against the backdrop of snow-capped mountains. In presenting such ordinary yet somewhat unexpected images in a manner that suggests the objectivity of the documentary, Shahbazi upends Western perceptions of life in Iran.

In the images that make up *Goftare Nik*'s compendium of Iranian life, women are perhaps the most common subjects. These images of women, with and without veils, are what locate these photographs culturally, serving both as a marker of difference and as a means of challenging and dismantling the clichés of this difference. Shahbazi's images of women contradict Western assumptions about the Islamic Revolution of 1979 and the restrictions placed on women's dress and behavior. In Shahbazi's images, women smoke, use nail polish and makeup, have professional jobs, and wear Western clothes. A number of these images in fact focus on brides posing in traditional Western white wedding gowns (fig. 72).

72
Shirana Shahbazi
From *Goftare Nik / Good Words*, 2000–2003
Cat. no. 62

73
Shirana Shahbazi
From *Goftare Nik / Good Words*, 2000–2003
Cat. no. 62

Holding their bridal bouquets, these young women adopt romantic, almost saccharine poses, seemingly unconcerned that they are in defiance of the traditional Islamic dress code.

If Shahbazi's photographs in *Goftare Nik* are dominated by such contradictory depictions of women, so too are her images made in collaboration with billboard painters. Employing a style generally associated with product advertising or with images of the Ayatollah, Shahbazi's painted images usually feature veiled women and their children (fig. 73). In merging these seemingly incongruous genres, Shahbazi offers heroic and often larger-than-life images of Iranian women, presenting new icons of Islamic culture and further destabilizing the pictorial clichés associated with her native country.

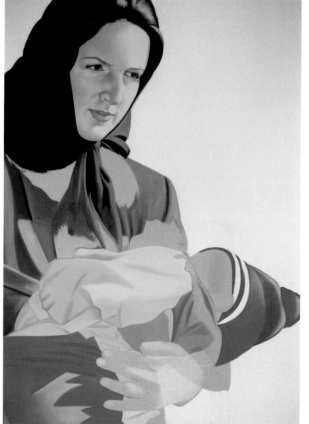

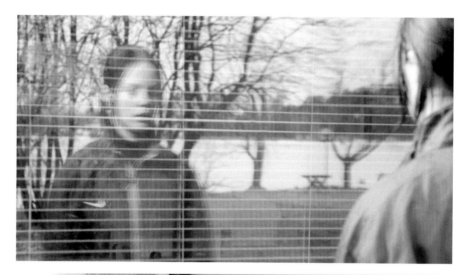

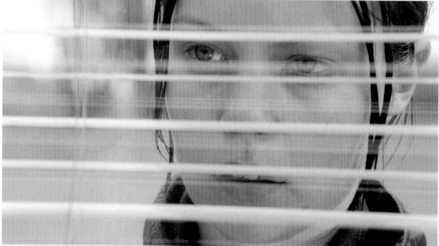

77
Salla Tykkä
Stills from *Lasso*, 2000
35mm film on video
3:48 min.
Courtesy of the artist and Galerie Yvon Lambert,
Paris and New York

Oblique and poetic, Salla Tykkä's photography and video works are characterized by their subjectivity and power. Born and raised in Helsinki, Tykkä belongs to a generation of Nordic artists whose work is informed by feminism and postmodernism, as well as by diverse cinematic traditions—from Ingmar Bergman to Hollywood. Echoing Bergman's emphasis on emotions, adopting key strategies of the Hollywood pop film, and working within an established feminist tradition in which the artist is the subject matter, Tykkä's works address the power relations of gender constructs. The common theme in her art—whether it is addressing social pathology or key life transitions of girlhood, puberty, and womanhood—is empowerment. From early works dealing with emotional pain and self-destructive behavior to powerful videos about sexual awakening, such as *Lasso* and *Thriller*, the artist's focus has been personal awareness.

Tykkä's penchant for bold portrayals of internal struggles is already evident in an early photographic series including three works entitled *Sick*, *More Sick*, and *The Sickest One* (1997; figs. 14–16), which reveal the anguish of her battle with anorexia during her years in art school. In *Sick*, a dazed young woman sits alone at a table in a cafeteria in front of an uneaten meal as a trickle of blood runs down the side of her face from her ear. Her condition worsens in *More Sick*, as she lies exhausted on a hospital gurney surrounded by vomit and bottles of water. Finally, in *The Sickest One*, wearing a T-shirt with the word *girl* emblazoned across her chest, she is flushed and has broken into a hot sweat, perhaps from fever or physical exertion. Tykkä has written of these unsettling works: "All of my pictures were autoportraits and they were telling mainly about the obsession of being a perfect looking woman. . . . I was suffering from anorexia for many years. I tried to figure out the reasons for my sickness. The series tells about the sick balance between eating and burning calories."[1]

From these emotional early photographic works and related videos such as the raw and autobiographical *My Hate Is Useless* (1996), Tykkä moved on to create *Lasso* (2000; figs. 77, 78), a watershed video work that defined a number of her now-ongoing thematic and formal concerns. Meticulously structured, romantic, and elliptical, this short, three-minute sequence features a highly charged event that addresses voyeurism and desire. *Lasso* begins with a young girl in a jogging suit running through a suburban Helsinki neighborhood and approaching a house. When no one answers the door, she runs around to the back of the house and looks through a large window and partially opened blinds to see a young, bare-chested man skillfully twirling a lasso in the middle of the living room. A sound track featuring Ennio Morricone singing "Once upon a Time in the West" contributes to the initial humor of this sequence. The young girl is transfixed by the dramatic and surprisingly intimate scene unfolding in front of her as the young man, oblivious to her presence and totally absorbed in his activity, continues to jump through the lasso until he ultimately snaps it to the ground. As if to avoid being detected, the young girl then slowly backs away from the window and retreats from the house.

Since *Lasso* stops short of explanation, much is left to the viewer to decipher. Particularly in question is the nature of the relationship of the girl to the young man. Is this someone whom she has never seen before? Is this a friend? Or is this in fact her own house, which she has been locked out of, and the young man, her own brother? How we initially see this relationship ultimately colors our reading of this charged and voyeuristic incident. *Lasso*'s narrative economy not only allows for a variety of potential readings but also takes the images to a hybrid terrain where diverse film genres mingle: high melodrama and lowbrow tearjerker, film noir and music video, auteur film and Hollywood movie.

Tykkä's next video, entitled *Thriller* (2002; fig. 79), is a formally stunning and disturbing piece in which sexuality and violence combine in a sequence bordering on the demonic. Dressed in red, *Thriller*'s young protagonist stands out in an otherwise subdued scene set in and around an old Helsinki farmhouse. As the piece begins, the girl lies on her bed and clutches her arms around her body nervously as a man (her father?) leads a sheep through the woods outside, while a woman (her mother?) gathers branches for a bonfire. The girl becomes increasingly agitated as we watch her brooding in her room, her intense stares and an ominous sound track foreshadowing the aggression to come. In the climactic sequence, she moves outside the house and runs through the woods to a small cabin, where she picks up a rifle. The piece culminates in an act of violence toward the sheep. Tykkä writes of this work, "In *Thriller*, I represent the main character's sexual awakening and her need to identify, on the threshold of adulthood and understanding."[2] As we see the sheep lying dead on the ground at the close of the video, we begin to understand the depth of the young girl's emotions. *Thriller* boldly articulates Tykkä's essential themes of self-awareness and empowerment while introducing highly cinematic images and evocative and open-ended narrative fragments.

NOTES

1. Salla Tykkä, Projects: *Healthy Young Female*, 12 May 2003
 <http://www.muu.fi/salla/healthy.htm>.
2. Salla Tykkä, Projects: *Thriller*, 12 May 2003
 <http://www.muu.fi/salla/thriller.htm>.

Salla Tykkä
Stills from *Lasso*, 2000
35mm film on video
3:48 min.
Courtesy of the artist and Galerie Yvon Lambert,
Paris and New York

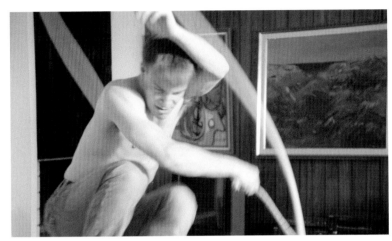

79
Salla Tykkä
Stills from *Thriller*, 2001
Cat. no. 67

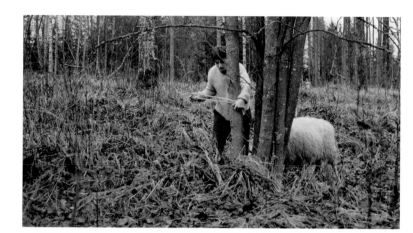

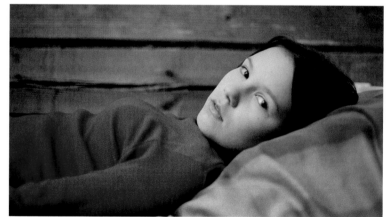

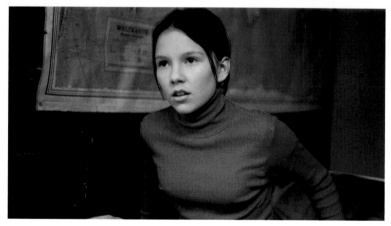

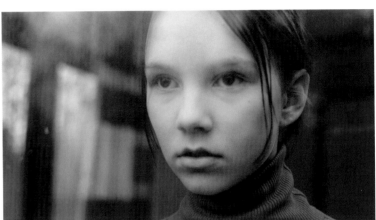
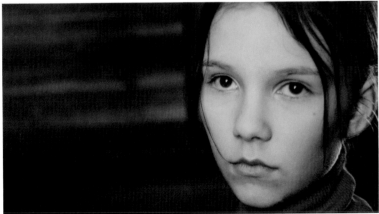
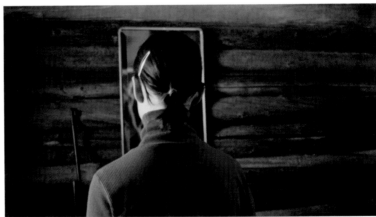

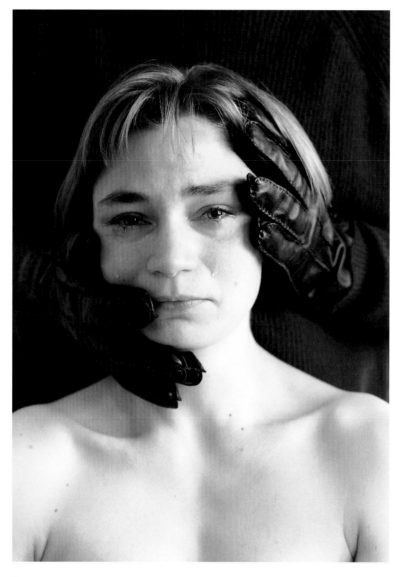

80
Elina Brotherus
Epilogue, 1999
Cat. no. 8

EIJA-LIISA AHTILA

1
Lahja—The Present, 2001
Written and directed by Eija-Liisa Ahtila
Copyright and produced by Crystal Eye, Helsinki
Five-monitor installation on DVD-ROM with stereo sound
Variable duration
Orange County Museum of Art; Museum purchase with funds
provided through prior gift of Lois Outerbridge
Courtesy Klemens Gasser & Tanja Grunert, New York

ELINA BROTHERUS

2
Lesson, 1998
Single-channel video
8:45 min.
Courtesy &: gb agency, Paris

3
Self-Portraits with a Dancer I, 1998
Chromogenic process color print
31 1/2 x 37 in. (80 x 94 cm)
Courtesy &: gb agency, Paris

4
Self-Portraits with a Dancer II, 1998
Chromogenic process color print
31 1/2 x 37 in. (80 x 94 cm)
Courtesy &: gb agency, Paris

5
Self-Portraits with Self-Portraits IV, 1998
Chromogenic process color print
31 1/2 x 39 3/8 in. (80 x 100 cm)
Courtesy &: gb agency, Paris

6
Chalon-sur-Saône 6, 1999
Chromogenic process color print
41 5/16 x 53 in. (105 x 135 cm)
Courtesy &: gb agency, Paris

7
Contente enfin? 1999
Chromogenic process color print
27 1/2 x 35 in. (70 x 88 cm)
Courtesy &: gb agency, Paris

8
Epilogue, 1999
Chromogenic process color print
27 1/2 x 19 11/16 in. (70 x 50 cm)
Courtesy &: gb agency, Paris

9
False Memories II, 1999
Chromogenic process color print
27 1/2 x 27 1/2 in. (70 x 70 cm)
Courtesy &: gb agency, Paris

10
The Fundamental Loneliness, 1999
Chromogenic process color print
27 1/2 x 19 11/16 in. (70 x 50 cm)
Courtesy &: gb agency, Paris

11
Love Bites II, 1999
Chromogenic process color print
27 1/2 x 23 in. (70 x 58 cm)
Courtesy &: gb agency, Paris

12
Revenue, 1999
Chromogenic process color print
31 1/2 x 24 1/2 in. (80 x 62 cm)
Courtesy &: gb agency, Paris

13
Homme derrière un rideau, 2000
Chromogenic process color print
31 1/2 x 26 in. (80 x 66 cm)
Courtesy &: gb agency, Paris

14
Femme à sa toilette, 2001
Chromogenic process color print
31 1/2 x 26 in. (80 x 66 cm)
Courtesy &: gb agency, Paris

15
Low Horizon 2, 2001
Chromogenic process color print
31 1/2 x 39 3/8 in. (80 x 100 cm)
Collection Isabel and Agustin Coppel

16
Le printemps, 2001
Chromogenic process color print
27 1/2 x 31 1/2 in. (70 x 80 cm)
Courtesy &: gb agency, Paris

17
Figure au bord de l'eau, 2002
Chromogenic process color print
31 1/2 x 40 1/8 in. (80 x 102 cm)
Courtesy &: gb agency, Paris

DORIT CYPIS

18
In Preparation for Flight, 2001
C-print
26 x 40 in. (66 x 101.6 cm)
Courtesy of the artist

19
Reversibility, 2001
C-print
Diptych, 40 x 60 in. (101.6 x 152.4 cm)
Courtesy of the artist

20
Dancer's Dilemma, 2002
C-print
48 1/2 x 64 5/8 in. (123.2 x 164.1 cm)
Courtesy of the artist

21
Inside-Out, 2002
C-print
25 3/4 x 38 3/4 in. (65.4 x 98.4 cm)
Courtesy of the artist

22
Mixed Motives, 2002
C-prints
Diptych, 40 x 60 in. (101.6 x 152.4 cm) each image
Courtesy of the artist

23
Prisoner's Dilemma 1, 2002
C-print
41 x 52 1/4 in. (104.1 x 130.2 cm)
Courtesy of the artist

24
Prisoner's Dilemma 2, 2002
C-print
41 x 52 1/4 in. (104.1 x 130.2 cm)
Courtesy of the artist

25
The Rest in Motion 1, 2002
C-print
42 x 57 3/4 in. (106.6 x 152.4 cm)
Courtesy of the artist

26
The Rest in Motion 2, 2002
C-print
42 x 57 3/4 in. (106.6 x 152.4 cm)
Courtesy of the artist

RINEKE DIJKSTRA

27
Kolobrzeg, Poland, July 26, 1992, 1992
C-print
56 11/16 x 47 1/4 in. (62 x 52 cm)
San Francisco Museum of Modern Art; fractional gift of
Shirley Ross Sullivan

28–33
Almerisa, 1994–2003
Almerisa, Asylumcenter Leiden, Leiden, Netherlands, March 14, 1994, 1994
Almerisa, Wormer, Netherlands, June 23, 1996, 1996
Almerisa, Wormer, Netherlands, February 21, 1998, 1998
Almerisa, Leidschendam, Netherlands, December 9, 2000, 2000
Almerisa, Leidschendam, Netherlands, April 13, 2002, 2002
Almerisa, Leidschendam, Netherlands, June 25, 2003, 2003
C-prints
24 3/8 x 20 1/2 in. (62 x 52 cm) each
Courtesy of the artist and Marian Goodman Gallery, New York

34
The Buzzclub, Liverpool, England / Mysteryworld, Zaandam,
Netherlands, 1996–97
Double projection, 35mm film with sound transferred to DVD
26:40 min.
Courtesy of the artist and Marian Goodman Gallery, New York

35
Erez, Golani Brigade, Elyakim, Israel, May 26, 1999, 1999
C-print
70 7/8 x 59 in. (180 x 150 cm)
Collection Isabel and Agustin Coppel

36
*Stephany, Saint Joseph Ballet, Orange County, California, USA, March
22, 2003*, 2003
C-print
49 5/8 x 42 1/8 in. (126 x 107 cm)
Courtesy of the artist and Marian Goodman Gallery, New York

KATY GRANNAN

37
Untitled (from the Poughkeepsie Journal), 1998
C-print, edition of 6
48 x 39 in. (121.9 x 99 cm)
Collection of Jeanne and Nicolas Rohatyn
Courtesy Artemis Greenberg Van Doren Gallery, New York

38
Untitled (from the Poughkeepsie Journal), 1998
C-print, edition of 6
48 x 39 in. (121.9 x 99 cm)
Courtesy Dorsey Waxter, Artemis Greenberg Van Doren Gallery,
New York

39
Barry, Bethlehem, PA, 2002
Gelatin silver print
20 x 16 in. (50.8 x 40.6 cm)
Courtesy of the artist and Artemis Greenberg Van Doren Gallery,
New York

40
Carla, Arnold Arboretum, Jamaica Plain, MA, 2002
C-print
48 x 60 in. (121.9 x 152.4 cm)
Courtesy of the artist and Artemis Greenberg Van Doren Gallery,
New York

41
Joline, Broad Top, PA, 2002
Gelatin silver print
20 x 16 in. (50.8 x 40.6 cm)
Courtesy of the artist and Artemis Greenberg Van Doren Gallery,
New York

42
Brandi, Poughkeepsie, NY, 2003
Gelatin silver print
20 x 16 in. (50.8 x 40.6 cm)
Courtesy of the artist and Artemis Greenberg Van Doren Gallery,
New York

43
Dee, Red Hook, NY, 2003
Gelatin silver print
20 x 16 in. (50.8 x 40.6 cm)
Courtesy of the artist and Artemis Greenberg Van Doren Gallery,
New York

44
Meghan, Red Hook, NY, 2003
Gelatin silver print
20 x 16 in. (50.8 x 40.6 cm)
Courtesy of the artist and Artemis Greenberg Van Doren Gallery,
New York

45
Valerie, Valatie, NY, 2003
Gelatin silver print
20 x 16 in. (50.8 x 40.6 cm)
Courtesy of the artist and Artemis Greenberg Van Doren Gallery,
New York

46
Van, Red Hook, NY, 2003
Gelatin silver print
20 x 16 in. (50.8 x 40.6 cm)
Courtesy of the artist and Artemis Greenberg Van Doren Gallery,
New York

SARAH JONES

47
Consulting Room Couch (XIV), 1997
C-print on aluminum
60 x 60 in. (150 x 150 cm)
Collection Laura Steinberg and B. Nadal-Ginard, Chestnut Hill,
Massachusetts
Courtesy Anton Kern Gallery, New York

48
The Dining Room (Francis Place) (III), 1997
C-print on aluminum
60 x 60 in. (150 x 150 cm)
Courtesy of the artist and Maureen Paley Interim Art, London

49
The Sitting Room (Francis Place) (V), 1997
C-print on aluminum
60 x 60 in. (150 x 150 cm)
Courtesy Anton Kern Gallery, New York

50
The Spare Room (Francis Place) (V), 1998
C-print on aluminum
60 x 60 in. (150 x 150 cm)
Courtesy Anton Kern Gallery, New York

51
The Wall (Francis Place) (I), 1999
C-print on aluminum
60 x 60 in. (150 x 150 cm)
Collection Danielle and David Ganek, Greenwich, Connecticut
Courtesy Anton Kern Gallery, New York

52
The Park, 2002
C-print on aluminum
60 x 60 in. (150 x 150 cm)
Collection Darrel and Marsha Anderson, Newport Beach
Courtesy Maureen Paley Interim Art, London

KELLY NIPPER

53
interval, 2000
Four framed chromogenic process color prints
39 3/4 x 50 5/8 in. (100.9 x 128.6 cm) each
Collection Orange County Museum of Art; Museum purchase
with funds provided through prior gift of Lois Outerbridge

54
Bending Water into a Heart Shape, 2003
Four video projections with sound: LCD projectors,
DVD players, speakers
Variable duration
Camera, sound, editing: Peter Kirby
Lighting: Andy Strauss
Production assistant: Paul Dove
Digital background painting: Angela Diamos
Camera and sound equipment: Production Gear Rental
Movement: Phithsamay Linthahane
Figure skating instruction: Mary Couense
Internal martial arts instruction: Joseph Zeisky
Turntable fabrication: Advanced Industries
Mobile fabrication: Joseph Hammer
Packaging design: Michael Worthington with Adam King
DVD transfer: DVD Master
Courtesy galleria francesca kaufmann, Milan

DANIELA ROSSELL

55
Untitled (Ricas y famosas), 1999
Mexico City
C-print, edition of 5
40 x 30 in. (101.6 x 76.2 cm)
Courtesy Greene Naftali Inc., New York

56
Untitled (Ricas y famosas), 1999
Mexico City
C-print, edition of 5
30 x 40 in. (76.2 x 101.6 cm)
Courtesy Greene Naftali Inc., New York

57
Untitled (Ricas y famosas), 1999
Mexico City
C-print, edition of 5
30 x 40 in. (76.2 x 101.6 cm)
Courtesy Greene Naftali Inc., New York

58
Untitled (Ricas y famosas), 1999
Mexico City
C-print, edition of 5
50 x 60 in. (76.2 x 101.6 cm)
Courtesy Greene Naftali Inc., New York

59
Untitled (Ricas y famosas), 1999
Mexico City
C-print, edition of 5
50 x 60 in. (127 x 152.4 cm)
Courtesy Greene Naftali Inc., New York

60
Untitled (Ricas y famosas), 2001
Monterrey, Mexico
C-print, edition of 5
50 x 60 in. (127 x 152.4 cm)
Courtesy Greene Naftali Inc., New York

61
Untitled (Ricas y famosas), 2002
Mexico City
C-print, edition of 5
30 x 40 in. (76.2 x 101.6 cm)
Courtesy Greene Naftali Inc., New York

62
Goftare Nik / Good Words, 2000–2003
Twenty-three C-prints
Dimensions variable
Courtesy Galerie Bob van Orsouw, Zurich

SALLA TYKKÄ

63–65
Sick, 1997
More Sick, 1997
The Sickest One, 1997
C-prints
23 x 19 3/4 in. (58 x 50 cm) each
Courtesy of the artist and Galerie Yvon Lambert, Paris and New York

66
Thriller, 2001
35mm film on video
7:30 min.
Courtesy of the artist and Galerie Yvon Lambert, Paris and New York

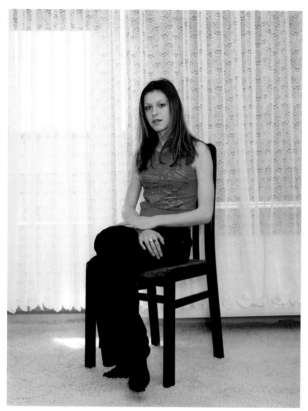 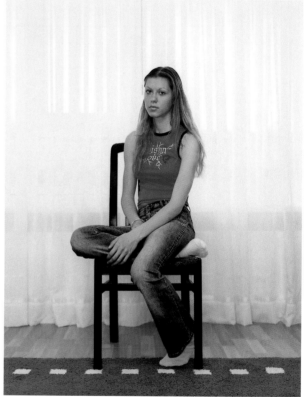

81, 82
Rineke Dijkstra
Almerisa, Leidschendam, Netherlands, April 13, 2002, 2002
Almerisa, Leidschendam, Netherlands, June 25, 2003, 2003
Cat. nos. 32, 33

EIJA-LIISA AHTILA

Born in Hämeenlinna, Finland, in 1959
Lives and works in Helsinki

EDUCATION
UCLA, Certificate Program, Film, TV, Theater, and Multimedia Studies, Los Angeles, 1994–95
American Film Institute, Advanced Technology Program special courses, Los Angeles, 1994–95
London College of Printing, School of Media and Management, Film and Video Department, 1990–91
Independent art school, 1981–84

SELECTED SOLO EXHIBITIONS
2003
De Appel, Amsterdam, the Netherlands
2002
Fantasized Persons and Taped Conversations, Kunsthalle, Zurich; Tate Modern, London; Kiasma—Museum of Contemporary Art, Helsinki (catalogue)
Klemens Gasser & Tanja Grunert, Inc., New York
2000
Neue Nationalgalerie, Berlin
Klemens Gasser & Tanja Grunert, Inc., New York
1999
Salzburger Kunstverein, Salzburg, Austria
Museum of Contemporary Art, Chicago
1998
Klemens Gasser & Tanja Grunert, Inc., New York
Museum Fridericianum, Kassel, Germany (catalogue)
1997
Klemens Gasser & Tanja Grunert, Cologne, Germany
Raum der aktuellen Kunst, Vienna
1996
Cable Gallery, Helsinki
1995
Gallery Index, Stockholm
1991
Kluuvin Galleria, Helsinki
1990
Young Artist of the Year, Tampere Art Museum, Tampere, Finland

SELECTED GROUP EXHIBITIONS
2003
Micropolitics: Art and the Quotidian, 2001–1968 (Part 1), EACC, Castellon, Spain
Away from Home, Wexner Center for the Arts, Columbus, Ohio

Home Sweet Home, Aarhus Kunstmuseum, Aarhus, Denmark
Centro nazionale per le arti contemporanee, Rome
2002
Documenta 11, Kassel, Germany
Biennial of Sydney 2002, Sydney, Australia
Never Ending Stories, Haus der Kunst, Munich, Germany
Beyond Paradise, Bangkok National Gallery
2001
Interferenze Nordic Countries, Palazzo delle Papesse, Siena, Italy
Screens and Projectors, Fundació "La Caixa," Barcelona
. . . troubler l'écho du temps, Musée Art contemporain, Lyon, France
Blick nach vorn, Museum Abteiberg, Mönchengladbach, Germany
2000
Eija-Liisa Ahtila and Ann-Sofi Sidén, Contemporary Arts Museum, Houston
Kwangju Biennial, Kwangju, South Korea
Institute of Contemporary Art, Boston
Organising Freedom, Moderna Museet, Stockholm
1999
Melbourne International Biennial
Kaiser Wilhelm Museum, Krefeld, Germany
Rewind to the Future, Bonner Kunstverein, Bonn
Seeing Time: Selections from the Pamela and Richard Kramlich Collection of Media Art, San Francisco Museum of Modern Art (catalogue)
End of Story, Nordic Pavilion, Venice Biennale, Venice, Italy
Cinema Cinema: Contemporary Art and the Cinematic Experience, Stedelijk Van Abbemuseum, Eindhoven, the Netherlands
1998
Nordic Nomads, White Columns, New York (catalogue)
Manifesta 2, Luxembourg (catalogue)
Aavan meren tällä puolen / Härom de stora haven / This Side of the Ocean, Kiasma—Museum of Contemporary Art, Helsinki (catalogue)
Nuit Blanche, Musée d'Art Moderne de la Ville de Paris (catalogue)
1997
Nordic Female Art, Skanska Konstmuseum, Lund, Sweden
Fifth Istanbul Biennial 1997, Istanbul (catalogue)
Zones of Disturbance, Steirischer Herbst, Graz, Austria (catalogue)
ID, Van Abbemuseum, Eindhoven, the Netherlands (catalogue)
Found Footage, Klemens Gasser & Tanja Grunert, Cologne (catalogue)
Now Here, Louisiana Museum of Modern Art, Humlebaek, Denmark (catalogue)
1995
Rooseum—The Center for Contemporary Art, Malmö, Sweden
1994
Identity, Museum of Contemporary Art, Helsinki

ELINA BROTHERUS

Born in Helsinki in 1972
Lives and works in Helsinki and in France

EDUCATION
M.A., photography, University of Art and Design, Helsinki, 2000
M.S., analytic chemistry, University of Helsinki, 1997

SELECTED SOLO EXHIBITIONS
2003
Spring, Kunsthalle Lophem, Bruges, Belgium
Festival Foto-Encuentros, Murcia, Spain (catalogue)
2002
Hämeenlinna Art Museum, Hämeenlinna, Finland; Västeras Art
 Museum, Västeras, Sweden; Lund Art Hall, Lund, Sweden
 (catalogue)
Photographic Works, 1997–2001, *Photo-España*, Botanical Gardens,
 Madrid (catalogue)
The New Painting, INOVA, Institute of Visual Art, Milwaukee
 (catalogue)
2001
Suites françaises 2, &:gb agency, Paris (catalogue)
Spring, The Wapping Project, London (catalogue)
2000
Encontros de Fotografia, Coimbra, Portugal (catalogue)
1999
Finnish Museum of Photography, Helsinki

SELECTED GROUP EXHIBITIONS
2003
*Transparente: Interni e estern*i, Centro Nazionale per le Arti
 Contemporanee, Rome
Zeitgenössische Fotokunst aus Finnland, Neue Berliner Kunstverein,
 Berlin; Mannheimer Kunstverein, Mannheim, Germany;
 Stadtgalerie, Kiel, Germany; Staatliche Kunstsammlung, Kottbus,
 Germany; Helsingin Taidehalli/Helsinki Kunsthalle (catalogue)
2002
Beyond Paradise, National Gallery, Bangkok; National Art Gallery,
 Kuala Lumpur, Malaysia; Fine Art Museum, Ho Chi Minh City,
 Vietnam; Fine Art Museum, Shanghai (catalogue)
Symptomania, Kunsthalle Lophem, Bruges, Belgium (catalogue)
Uusia kuvia, Brotherus Kella Kolehmainen Lajunen Parantainen, City
 Art Museum, Helsinki
Citigroup Private Bank Photography Prize, Photographers' Gallery,
 London (catalogue)
2001
ARS 01, Museum of Contemporary Art, Helsinki (catalogue)
Théâtre du fantastique, Printemps de Septembre, Toulouse, France
 (catalogue)
Fotofinlandia 2000 Award, The Cable Factory, Helsinki
2000
Jahresgaben, Frankfurter Kunstverein, Frankfurt
One of Those Days, Mannheimer Kunstverein, Mannheim, Germany
Norden/North, Kunsthalle Wien, Vienna
1999
The Passion and the Wave, Sixth International Istanbul Biennial

DORIT CYPIS

Born in Tel Aviv, Israel, in 1951
Lives and works in Los Angeles

EDUCATION
Master's in conflict resolution, Pepperdine University, Malibu,
 California, 2004
M.F.A., California Institute of the Arts, Valencia, 1977
B.F.A., B.A., art education, Nova Scotia College of Art and Design,
 Halifax, 1974

SELECTED SOLO EXHIBITIONS
2003
The Sound of Time, Galerie Optica, Montreal (video)
2001
Contingency (lui lui), Storage, Los Angeles
2000
Angel of Histories, Sweeney Art Gallery, University of California,
 Riverside (catalogue)
1998
Framing Memories I Never Had, Galerie de l'Université du Quebec,
 Montreal
1995
Hungry Ghost (and the Seven Muses), Krannert Art Museum,
 University of Illinois at Urbana-Champaign (catalogue)
1993
The Body in the Picture (Psycho Portraits), Isabella Stewart Gardner
 Museum, Boston (catalogue)
1992
If You Fear Me . . . You Will Lose Me, Catherine G. Murphy Gallery,
 College of Saint Catherine, Saint Paul
1991
Odalisque (The Devil in Miss Jones), Roy Boyd Gallery, Santa Monica,
 California
The Inquisition (based on the film *The Devil in Miss Jones* [Gerald
 Damiano, 1973]), Out There Performance Series, Walker Art
 Center and Southern Theater, Minneapolis (video, brochure)
1989
X-Rayed (Altered), Intermedia Arts and First Bank System,
 Minneapolis; Anderson Gallery, Virginia Commonwealth
 University, Richmond (brochures)
The Naked Nude, International Center of Photography, New York
 (brochure)
1988
X-Rayed, New American Filmmakers, Whitney Museum of
 American Art, New York (brochure)
Threshold in Musical Time I (with Butoh dancer Tomiko Takai), Space
 AD 2000, Tokyo
1987
Phantasmagoria, Anna Leonowens Gallery, Nova Scotia College of
 Art and Design, Halifax
1986
The Artist and Her Model, De Zaak, Groningen, the Netherlands
 (video)
1983
Still Cinema: Talking Pictures, Grande Theater, Groningen, the
 Netherlands; Apollohuis, Eindhoven, the Netherlands; T'Hoogt,
 Utrecht, the Netherlands
1982
The Quest of the Impresario: A Re-emergence, A Space, Toronto;
 Vehicule Galerie, Montreal
The Quest of the Impresario: Courage, Los Angeles Contemporary
 Exhibitions

SELECTED GROUP EXHIBITIONS

2002

Democracy When? UCLA Hammer Museum and Los Angeles
 Contemporary Exhibitions (catalogue)

Forgotten Evidence, San Francisco Superior Courthouse, San Francisco
 Art Institute

1999

The Great Atrophy, Hay-Art Cultural Center, Yereven, Armenia

1998

Sculpture on Site, Walker Art Center, Minneapolis (catalogue)

1997

Defining Eye: Women Photographers of the Twentieth Century, Saint
 Louis Art Museum; UCLA Hammer Museum, Los Angeles;
 National Museum of Women in the Arts, Washington, D.C.

1996

Gender Affects, Fine Arts Gallery (and the Kinsey Institute for
 Research in Sex, Gender and Reproduction), Indiana University,
 Bloomington (catalogue)

1994

*Double Take, Power, Pleasure, Pain: Contemporary Women Artists and the
 Female Body*, Fogg Art Museum, Harvard University, Cambridge

1993

Fictions of the Self: The Portrait in Contemporary Photography,
 Weatherspoon Art Gallery, University of North Carolina,
 Greensboro; Herter Art Gallery, University of Massachusetts,
 Amherst (catalogue)

1991

The Projected Image, 1970–1990, San Francisco Museum of Modern
 Art, San Francisco (brochure)

1989

Witnesses: Against Our Vanishing, Artist Space, New York (catalogue)

The Photography of Invention: American Pictures of the 80's, National
 Gallery of American Art, Smithsonian Institution, Washington,
 D.C.; Museum of Contemporary Art, Chicago; Walker Art
 Center, Minneapolis (catalogue)

1988

*Utopia Post Utopia: Configurations of Nature and Culture in Recent
 Sculpture and Photography*, Institute of Contemporary Art, Boston
 (catalogue)

1987

Sexual Difference: Both Sides of the Camera, Center for Exploratory and
 Perceptual Art (CEPA), Buffalo, New York; Miriam and Ira D.
 Wallach Art Gallery, Columbia University, New York (catalogue)

1986

Three Photographers: The Body, New Museum, New York (catalogue)

Au coeur du maelstrom, Palais des Beaux-Arts, Brussels (catalogue)

1985

Seduction and the Working Photograph, White Columns, New York

1983

Film as Installation, Clocktower Gallery, New York (catalogue)

RINEKE DIJKSTRA

Born in Sittard, the Netherlands, in 1959
Lives and works in Amsterdam

EDUCATION

Gerrit Rietveld Academy, Amsterdam, 1981–86

SELECTED SOLO EXHIBITIONS

2002

Art & Public, Geneva

2001

Rineke Dijkstra, Tiergarten Berlin / Olivier Silva, Frans Halsmuseum
 (De Hallen), Haarlem, the Netherlands

Sommer Contemporary Art, Tel Aviv, Israel

Galerie Max Hetzler, Berlin

Art Institute of Chicago

2000

Marian Goodman Gallery, New York

Anthony d'Offay Gallery, London

1999

DAAD Galerie, Berlin

Museu d'Art Contemporani de Barcelona

1998

Museum Boijmans Van Beuningen, Rotterdam

About the World, Sprengel Museum, Hannover, Germany

1997

Location, Photographers' Gallery, London

Galerie Mot & van den Boogaard, Brussels

1996

Le Consortium, Dijon, France

SELECTED GROUP EXHIBITIONS

2002

Remix: Contemporary Art & Pop, Tate Liverpool, Liverpool, England

Moving Pictures, Solomon R. Guggenheim Museum, New York

Performing Bodies, Moderna Museet, Stockholm

Picturing Ourselves: Behind the Mask of Portraiture, Worcester
 Museum, Worcester, Massachusetts

2001

At Sea, Tate Liverpool, Liverpool, England

Uniform–Order and Disorder, P.S. 1 Contemporary Art Center, Long
 Island City, New York

Platform of Humankind, Venice Biennale, Venice, Italy

2000

Little Angels, Houldsworth Fine Art, London

Eurovision, Saatchi Gallery, London

Conditions humaines, portraits intimes, Nederlands Foto Instituut,
 Rotterdam, the Netherlands

Let's Entertain: Life's Guilty Pleasures, Walker Art Center,
 Minneapolis; Portland Art Museum, Portland, Oregon; Centre
 Georges Pompidou, Paris (catalogue)

The Century of the Body: Photoworks, 1900–2000, Musée de l'Elysée,
 Lausanne, Switzerland

Breathless! Photography and Time, Victoria and Albert Museum,
 London

El mes de Holanda en el Museo, Museo Nacional de Bellas Artes,
 Buenos Aires, Argentina

Third International Month of Photography, Moscow House of
 Photography, Moscow

1999

Regarding Beauty: A View of the Late Twentieth Century, Hirshhorn
 Museum and Sculpture Garden, Washington, D.C.; Haus der
 Kunst, Munich, Germany (catalogue)

The Citigroup Private Bank Photography Prize, Photographers' Gallery,
 London

Modern Starts: People, Places, Things, Museum of Modern Art, New York (catalogue)

Glad ijs, Stedelijk Museum, Amsterdam, the Netherlands

1998

Sightings: New Photography Art, Institute of Contemporary Art, London

Wounds: Between Democracy and Redemption in Contemporary Art, Moderna Museet, Stockholm

Rineke Dijkstra, Tracy Moffatt, Fiona Tan, Museum van Hedendaagse Kunst, Ghent, Belgium

Twenty-fourth São Paulo Bienal, São Paulo, Brazil

Berlin Biennial, Berlin

The History of Photography, Canon Photography Gallery of the Victoria and Albert Museum, London

Global Vision: New Art From the 90's, Part III, Deste Foundation, Athens

1997

Face to Face, Nederlands Foto Instituut, Rotterdam

Venice Biennale, Venice, Italy

Rotterdam 97 Festival, Museum Boijmans Van Beuningen, Rotterdam

New Photography 13, Museum of Modern Art, New York

Triptych: Een blik op Nederlands realisme / A Review of Twentieth-Century Dutch Realism, Museum Bommel van Dam, Venlo

Pose, foto's uit de collectie, Stedelijk Museum, Amsterdam

1996

Zeitgenössische Fotokunst aus den Niederlanden, Neuer Berliner Kunstverein, Berlin; Badischer Kunstverein; Karlsruhe, Germany; Hallescher Kunstverein, Halle, Germany

Prospekt 96, Schirn Kunsthalle, Frankfurt am Main, Germany

1995

The European Face, Talbot Rice Gallery, Edinburgh, Scotland; Weesper Synagoge, Weesp, the Netherlands

Rineke Dijkstra, Tom Claasen, Stedelijk Museum Bureau, Amsterdam

Born in Arlington, Massachusetts, in 1969
Lives and works in Brooklyn

EDUCATION
M.F.A., Yale University, New Haven, 1999
B.A., University of Pennsylvania, 1991

SELECTED SOLO EXHIBITIONS

2003
Artemis Greenberg Van Doren Gallery, New York
Salon 94, New York

2001
Dream America, 51 Fine Art, Antwerp, Belgium

2000
Dream America, Lawrence Rubin Greenberg Van Doren, New York
Dream America, Kohn Turner Gallery, Los Angeles

SELECTED GROUP EXHIBITIONS

2003
Guided by Heroes, curated by Raf Simons, Z33, Hasselt, Belgium
Imperfect Innocence: The Debra and Dennis Scholl Collection, Contemporary Museum, Baltimore; Palm Beach Institute of Contemporary Art, Palm Beach, Florida

2002
The Norman Dubrow Biennial, Kagan Martos Gallery, New York
Women by Women, Cook Fine Art, New York

2001
Boomerang: Collector's Choice II, Exit Art, New York
Casino 2001, Stedelijk Museum Voor Actuel Kunst, Ghent, Belgium
Legitimate Theater, Los Angeles County Museum of Art
Tell It Like It Is, Diehl Vorderwuelbecke, Berlin
Dreaming in Print: Visionaire Ten-Year Anniversary Exhibition, Fashion Institute of Technology, New York
Smile, Here, New York

2000
Reflections through a Glass Eye, International Center for Photography, New York
Bluer, Carrie Secrist Gallery, Chicago
Kohn Turner Gallery, Los Angeles

1999
Another Girl, Another Planet, Lawrence Rubin Greenberg Van Doren Fine Art, New York
Female, curated by Vince Aletti, Wessel + O'Connor Gallery, New York

1998
DFN Gallery, New York
A&A Gallery, New Haven, Connecticut
ArtSpace, New Haven, Connecticut

Born in London in 1959
Lives and works in London

EDUCATION
M.A., Goldsmiths' College, London, 1994–96
B.A. Hons., Goldsmiths' College, London, 1978–81

SELECTED SOLO EXHIBITIONS
2002
Maureen Paley Interim Art, London
Anton Kern Gallery, New York
2000
Le Consortium, Dijon (as part of *I Love Dijon*)
Huis Marseille Foundation for Photography, Amsterdam
1999
Folkwang Museum, Essen, Germany
Anton Kern Gallery, New York
Centre for Photography, Universidad de Salamanca, Salamanca, Spain
Museum Reina Sofia, Madrid
Maureen Paley Interim Art, London
1998
Galerie Anne de Villepoix, Paris
L'Ecole supérieure des Beaux-Arts, Tours, France
Sites, Sabine Knust Galerie and Edition Maximilian Verlag, Munich
1997
Le Consortium, Dijon, France
Maureen Paley Interim Art, London
1995
Consulting Room (Couch), Camerawork Gallery, London
1993
Hales Gallery, London
1988
Watershed Arts Centre, Bristol, England
1987
F.Stop Gallery, Bath, England

SELECTED GROUP EXHIBITIONS
2003
Painting Pictures, Kuntsmuseum, Wolfsburg
2002
Die Wohltat der Kunst: Post\Feministische Positionen der 90er Jahre aus der Sammlung Goetz, Staatliche Kunsthalle, Baden-Baden
2001
Representing Britain, Tate Britain
No World without You: Reflections of Identity in New British Art, Herzliya Museum of Art, Herzliya, Israel
2000
Pause/Pose, Galerie Anne de Villepoix, Paris
Quotidiana, Castello di Rivoli, Turin
1999
Another Girl Another Planet, Lawrence Rubin Greenberg Van Doren Fine Art, New York
Third International Tokyo Photo Biennial, Tokyo Metropolitan Museum of Photography
1998
Dijon/le consortium.coll, tout contre l'art contemporain, Centre Georges Pompidou, Paris
Sorted, Ikon Gallery, Birmingham, England
1997
Portrait, Maureen Paley Interim Art, London
Dramatically Different, Galeries du Magasin, Centre National d'art Contemporain de Grenoble, France
On the Bright Side of Life—Contemporary British Photography, Neue Gesellschaft für bildende Kunst e.V., Berlin
1996
New Contemporaries, Tate Gallery, Liverpool; Camden Arts Centre, London
1995
Sick, 152c Brick Lane, London

Born in Edina, Minnesota, in 1971
Lives and works in Los Angeles

EDUCATION
M.F.A., California Institute of the Arts, Valencia, 1995
B.F.A., Minneapolis College of Art and Design, Minneapolis, 1993

SELECTED SOLO EXHIBITIONS
2002
Shoshana Wayne Gallery, Santa Monica, California
The Verge: Kelly Nipper, Plains Art Museum, Fargo, North Dakota (brochure)
Galleria Francesca Kaufmann, Milan
2001
shotgun and a figure 8, Shoshana Wayne Gallery, Santa Monica, California

SELECTED GROUP EXHIBITIONS
2003
Short Cuts: Video Art and Photography, Israel Art Museum, Jerusalem
2002
People See Paintings, Museum of Contemporary Art, Chicago
Pictures, Greene Naftali Gallery, New York
2001
A Sport and a Pastime, Greene Naftali Gallery, New York
A Passion for Art: The DiSaronno Originale Photography Collection, Miami Art Museum; Museum of Contemporary Art, Chicago; New Museum, New York; Museum of Art at the University of California, Berkley (brochure)
2000
Guarene Arte 2000, Fondazione Sandretto Re Rebaudengo, Turin, Italy (catalogue)
Sharon Lockhart + Kelly Nipper: Two Artists in Three Takes, San Francisco Art Institute (catalogue)

DANIELA ROSSELL

Born in Mexico City in 1973
Lives and works in Mexico City

EDUCATION
Undergraduate studies, National School of Visual Arts, U.N.A.M.,
 Mexico City, 1994
Theater studies, Mexico City, 1989

SELECTED SOLO EXHIBITIONS
2003
Artpace, San Antonio, Texas
2002
Third World Blondes Have More Money, Greene Naftali Inc., New York
Ricas y famosas, PhotoEspana 2002, Casa de America, Madrid
2000
All the Best Names Are Taken, Greene Naftali Inc., New York
1996
RVSP, Galeria OMR, Mexico City

SELECTED GROUP EXHIBITIONS
2002
Sublime Artificial, La Capella, Barcelona, Spain; San Diego
 Museum of Art, San Diego
Excess, Palm Beach Institute of Contemporary Art, Palm Beach,
 Florida
*Mexico City: An Exhibition about the Exchange Rates of
Bodies and Values*, P.S.1 Contemporary Art Center, Long Island City,
 New York
Axis Mexico: Common Objects and Cosmopolitan Acts, San Diego
 Museum of Art
2001
Phoenix Triennial 2001, Phoenix Art Museum
1999
ARCO'99, Madrid
Art Chicago '99, Chicago
1998
Mexcelente, Yerba Buena Center for the Arts, San Francisco
1997
The Conceptual Trend: Six Artists from Mexico City, El Museo del
 Barrio, New York
InSite '97: New Projects in Public Spaces by Artists of the Americas, San
 Diego, California, and Tijuana, Mexico
1996
Tendencies: New Art from Mexico City, Contemporary Art Gallery,
 Vancouver

SHIRANA SHAHBAZI

Born in Teheran, Iran, 1974
Lives and works in Zurich, Switzerland

EDUCATION
Hochschule für Kunst und Gestaltung, Zurich, 1997–2000
Fachhochschule Dortmund, 1995–97

SELECTED SOLO EXHIBITIONS
2003
Goftare Nik / Good Words, Museum of Contemporary Photography,
 Columbia College, Chicago (brochure)
2002
Galerie Bob van Orsouw, Zurich
Bonner Kunstverein am August Macke Platz, Bonn
2001
Photographers' Gallery, London

SELECTED GROUP EXHIBITIONS
2003
Italian Pavilion, Venice Biennale, Venice, Italy
2002
The Citigroup Private Bank Photography Prize 2002, Photographers'
 Gallery, London
Protest! Respect! Kunsthalle, Saint Gall, Switzerland
2001
Iran, recorridos cruzados, Ministerio de Educacion Cultura y Deporte,
 Madrid
Das Versprechen der Fotografie, Schirn Kunsthalle, Frankfurt
Zurich—Urban Diary, Galerie Bob van Orsouw, Zurich

Born in Helsinki, Finland, 1973
Lives and works in Helsinki

EDUCATION
M.A. candidate, Academy of Fine Arts, Helsinki, 1999–present
B.A., Academy of Fine Arts, Helsinki, 1995–99

SELECTED SOLO EXHIBITIONS
2003
Collection Lambert, Avignon, France
Statens Museum for Kunst, Copenhagen
Bethanien, Berlin
Tramway, Glasgow, Scotland
Herbert F. Johnson Museum of Art, Ithaca, New York
2002
Kontti, Kiasma—Museum of Contemporary Art, Helsinki
BAWAG–Foundation, Vienna
Kunsthalle Bern, Bern, Switzerland
Galerie Yvon Lambert, Paris
2001
Delfina Project Space, London
1999
Power, Studio Mezzo, Helsinki

SELECTED GROUP EXHIBITIONS
2003
New Realities, Hasselblad Center, Gothenburg, Sweden
2001
Edstrandska Nordiska Stipendium, Malmö Konsthall, Malmö, Sweden
Galerie Yvon Lambert, Paris
Lithuanian Triennial, CAC, Vilnius, Lithuania
Fantasies, Sara Hildén Art Museum, Tampere, Finland
2001
Identity, Oulu Art Museum, Oulu, Finland
Venice Biennale, Venice, Italy
Bida, Valencia, Spain (catalogue)
1998
The Nude and the Masked, Helsinki City Art Museum
ArtGenda, Kulturhuset Stockholm

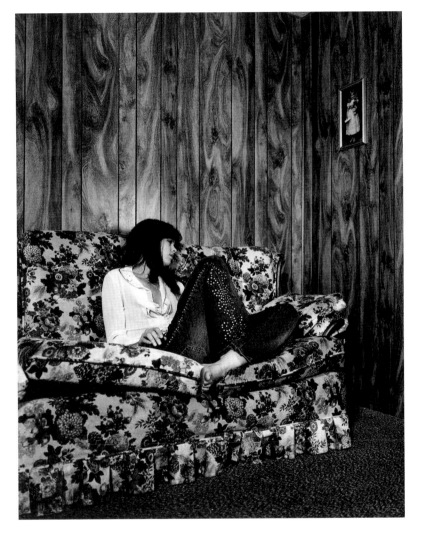

83
Katy Grannan
Jennifer, Easton, PA, 2001
Gelatin silver print
20 x 16 in. (50.8 x 40.6 cm)
Courtesy Artemis Greenberg Van Doren Gallery, New York

●● 134

STAFF

Elizabeth Armstrong
*Deputy Director for Programs and Chief
Curator*

Brian Boyer
Exhibitions and Facilities Manager

Earl Buck
Maintenance

Tom Callas
Registrar

David Curtius
Education and Outreach Coordinator

Ursula Cyga
Office Manager

Lisa Finizio
Associate Registrar

Irene Hofmann
Curator of Contemporary Art

Barrett Johnson
Maintenance

Jennifer Katz
Acting Director of Education

Joe Kearby
Development Systems Specialist

Thomas Keawe
Security

Brian Langston
Director of Marketing

Robert Laurie
Chief of Security

Nora Leysen
Museum Receptionist

Carol Lincoln
Accountant

Janet Lomax
Curatorial Assistant

Laurie McGahey
Associate Director of Development

Jeanine McWhorter
*Director of Visitor Relations and
Merchandising Services*

Hayley Miller
Assistant Store Manager

Anne Parilla
Development Assistant

Calleen Ringstad
Executive Assistant to the Director

Dan Rossiter
Chief Preparator

Robin Rutherford
Events Manager

Ron Scott
Director of Finance and Administration

Angela Suchey
Assistant Store Manager

Susan Swinburne
Director of External Affairs

Dennis Szakacs
Director

Joni Tom
Membership Manager

Tim Tompkins
Education Assistant

Sarah Vure
Curator of Collections

84
Daniela Rossell
Untitled (Ricas y famosas), 1999
Cat. no. 56